IMAGES
of America

LAKE SUPERIOR
COUNTRY

19TH CENTURY TRAVEL AND TOURISM

IMAGES
of America

LAKE SUPERIOR
COUNTRY
19TH CENTURY TRAVEL AND TOURISM

Troy Henderson

ARCADIA
PUBLISHING

Published by Arcadia Publishing
Charleston SC, Chicago IL, Portsmouth NH, San Francisco CA

Printed in the United States of America

Library of Congress Catalog Card Number: 2001098142

For all general information contact Arcadia Publishing at:
Telephone 843-853-2070
Fax 843-853-0044
E-mail sales@arcadiapublishing.com
For customer service and orders:
Toll-Free 1-888-313-2665

Visit us on the Internet at www.arcadiapublishing.com

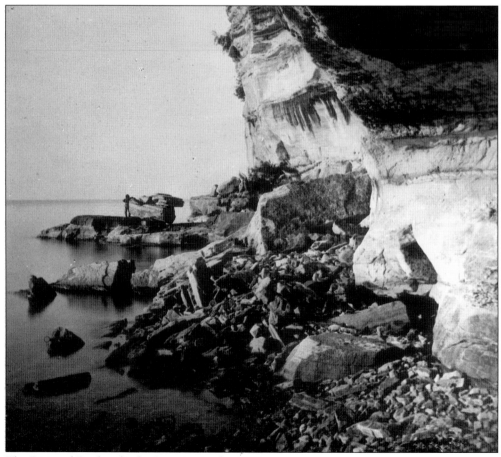

The Pictured Rocks of Lake Superior in the 1870s.

CONTENTS

ACKNOWLEDGMENTS

There are many individuals and organizations that have been of great help to me in creating this book. I would like to first thank Jack Deo of Marquette, who provided the bulk of the images for this book from his extraordinary photograph collection on the Upper Peninsula. I would also like to thank Meg Goodrich and the staff of the Marquette County Historical Society, the State Archives of Michigan, Thomas G. Friggens of the Michigan Iron Industry Museum, and the William L. Clements Library at the University of Michigan. In helping with my photography needs, I would like to thank Terry Ruff of Marquette and John Hillman of the Loyola University Center for Instructional Design. Thanks also to my advisor, Theodore J. Karamanski at Loyola University of Chicago and the Archivist at Loyola University of Chicago, Michael Grace SJ. Finally, I would like to thank my family, especially my wife Sarah for her support and understanding.

INTRODUCTION

Throughout the 19th century, travelers to Michigan's Upper Peninsula consistently called the region "Lake Superior," even when referring to overland journeys distanced from the great inland lake. The lake was of such importance to 19th-century travelers that boundaries between land and water seemed obscured.

The early 19th century saw the dawn of American exploration in the Upper Peninsula. After a failed exploration mission attempt in 1800, the United States government rebounded and organized an exploratory party in 1820 consisting of some 40 men. The governor of the Territory of Michigan, Lewis Cass, led the party, and aspiring young explorers like Henry Rowe Schoolcraft, David B. Douglass, and Charles C. Trowbridge began their careers. In some respects, the goals of the party were very similar to those of Lewis and Clark: to further the field of science by recording flora and fauna, examine the possible mineral deposits, and establish an American presence in the midst of the previously French and British dominated area. From roughly 1820 to 1840, explorers—often with government sponsorship and supervision—trekked the Lake Superior landscape with many of these same goals in mind. Following the cession of the land by the Native Americans, men like Douglas Houghton, Bela Hubbard, and William Austin Burt began to survey it.

Surveying and organizing the land Native Americans once held, in many ways led to another group of travelers, the "Literary Travelers." As America became more urban, many travelers sought a more romantic past, complete with rugged lands and what they called "wild Indians." They were literary because they wrote of their travels, but also because they were well acquainted with the literature about the region, such as Henry Wadsworth Longfellow's "The Song of Hiawatha," and other popular Native-American lore. These men and women traveled to the Lake Superior region in search of something rapidly disappearing in the United States—namely what they called the wilderness. They wanted to experience the picturesque, the sublime, and to escape growing cities like New York and Boston to temporarily enter the more "wild" region of the Upper Peninsula. They often retold Native-American legends in their travel journals, and tried to re-enter a world and a way of life that was in many ways gone.

With the opening of the Sault Ste. Marie canal in 1855, continuous travel from Lake Huron and Lake Michigan to Lake Superior became possible. Regular steamer routes began to connect growing towns in the Upper Peninsula, bringing a more structured form of travel. More tourists visited the region, and were equipped with published guidebooks rather than Native-American guides, who proved to be very helpful to earlier explorers. Travelers often took tours to the Pictured Rocks, and frequently inspected with great curiosity the vast copper and iron mining operations that were being undertaken.

In the 1870s and 1880s, railroad connections began to connect the Upper Peninsula from larger cities like Chicago and Detroit and they advertised for tourists to ride their lines through the region. For the first time, inland travel away from Lake Superior could be thoroughly undertaken. The camping, hunting, and fishing grounds of the Upper Peninsula were strong enticements for urban travelers. Furthermore, travel to the region from large cities was beginning to be measured in hours and not days.

This book will follow 19th-century travelers to the Lake Superior Country, from explorers who traversed Lake Superior in birch-bark canoes, like Henry Rowe Schoolcraft, to sportsmen and sportswomen in the latter part of the century who took advantage of the railroad connections to venture into the hunting and fishing grounds of inland Upper Peninsula. Sketches from travel narratives, maps, photographs, and railroad and steamer advertisements illustrate the story of travel and tourism to "Lake Superior Country." Quotations from the men and women who traversed the country, give readers a glimpse of how they viewed the Lake Superior landscape.

One

EXPLORERS

1820s–1850s

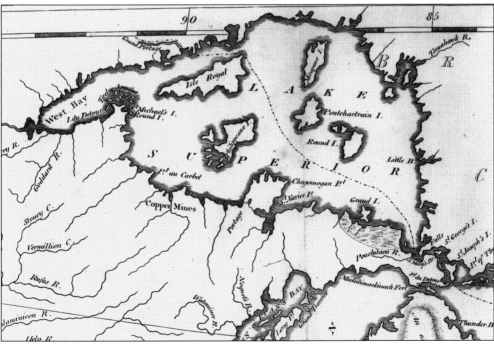

A 1795 MAP OF LAKE SUPERIOR BY SAMUEL LEWIS. The Copper Mines are identified on the southern shore of Lake Superior, as existence of these mines had been known by the French since the early 1600s. Despite this knowledge, the newly founded United States would not send official exploratory parties to the Lake Superior region until 1820. William Cooper, father of James Fenimore Cooper, initiated an early attempt in Congress to explore the region in 1800, but the plan failed due to political infighting. (From the Collection of the William L. Clements Library, University of Michigan.)

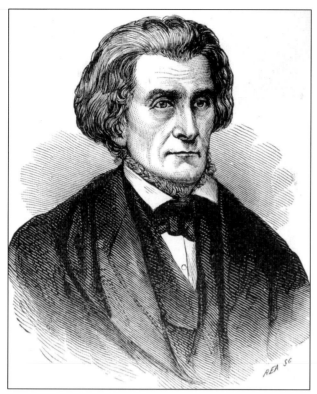

U.S. SECRETARY OF WAR JOHN C. CALHOUN. Calhoun served as Secretary of War from 1817 to 1825. Responsibilities of the Department of War at that time included "Indian Affairs." In this capacity, Calhoun granted Lewis Cass permission to organize an expedition to the Lake Superior Region in 1820, one of the goals of which was to acquire land owned by the Native Americans near Sault Ste. Marie for a military garrison. (From *Ridpath's Universal History, V. 15*, by John Clark Ridpath, 1897.)

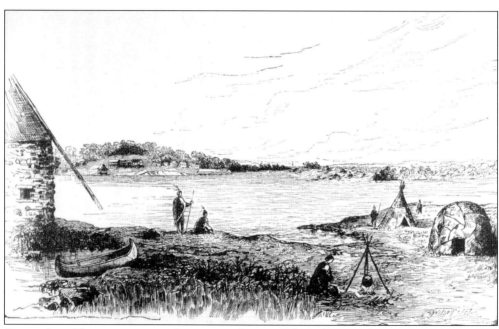

SAULT STE. MARIE FROM THE CANADIAN SHORE. When the expedition of 1820 arrived at Sault Ste. Marie, they were met by hostile Chippewas. Despite the initial hostilities, a treaty was made to secure a military garrison there. (From *Memorials of a Half-Century*, by Bela Hubbard, 1887.)

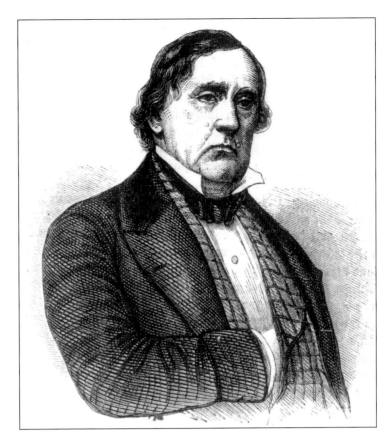

MICHIGAN TERRITORIAL GOVERNOR LEWIS CASS. Cass persuaded Secretary of War John C. Calhoun to organize the expedition of 1820. Cass himself led nearly 40 men into the Lake Superior wilderness. As the territorial governor, Cass was interested in opening the territory for settlement, since Michigan could not become a state until a certain population was reached in the territory. (From *Harper's Magazine* 1862–1863.)

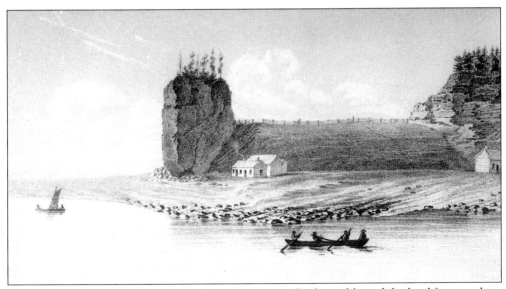

GROS CAP, NEAR THE ENTRANCE OF LAKE SUPERIOR. Explorers likened the land features there to the "Pillars of Hercules," which seemingly guarded the entrance to the lake. (From *Report on the Geology of the Lake Superior Land District, Part II*, By J.W. Foster and J.D. Whitney, 1851.)

11

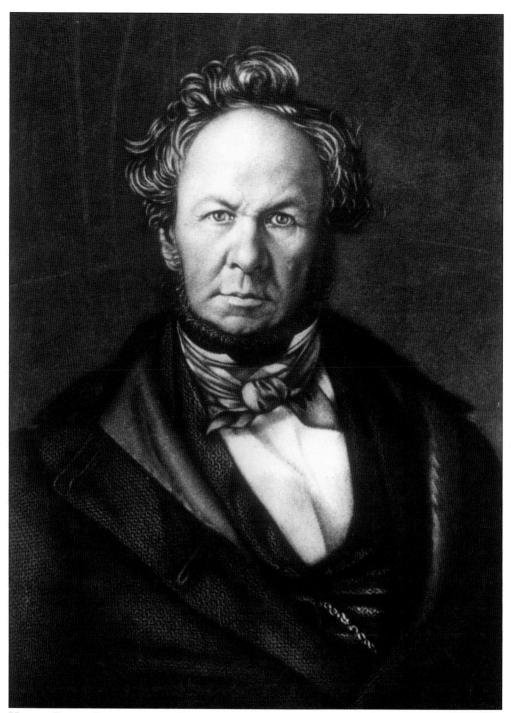

HENRY ROWE SCHOOLCRAFT, PROBABLY THE BEST-KNOWN LAKE SUPERIOR EXPLORER.
Schoolcraft took part in almost all important exploratory missions to Lake Superior from 1820
to the 1840s, and his writings on the subjects of exploration and the Native Americans are
voluminous. Schoolcraft's also frequented Mackinac Island and Sault Ste. Marie in the capacity
as an Indian Agent. (From the Collection of the Marquette County Historical Society.)

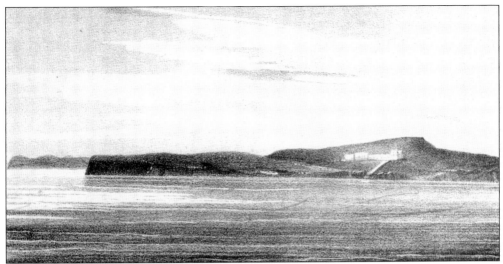

"REFRESHING SPECTACLE." The first sighting of Mackinac Island was an inviting view for travelers before entering Lake Superior. Henry Rowe Schoolcraft once wrote: "Nothing can present a more picturesque or refreshing spectacle to the traveler, wearied with the lifeless monotony of a canoe voyage through Lake Huron, than the first sighting of the Island of Michilimackinac." (From *Sketches of a Tour to the Lakes*, by Thomas L. McKenney 1827.)

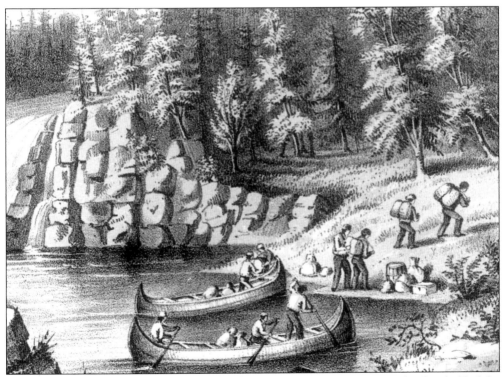

TOILS OF TRAVERSING. The toils of traversing Lake Superior Country in the first half of the 19th century were vast. One of the main tasks that awaited travelers was to regularly embark and disembark their canoes to portage and camp. (From *Report on the Geology of the Lake Superior Land District, Part I: Copper Lands*, by J.W. Foster and J.D. Whitney, 1850.)

13

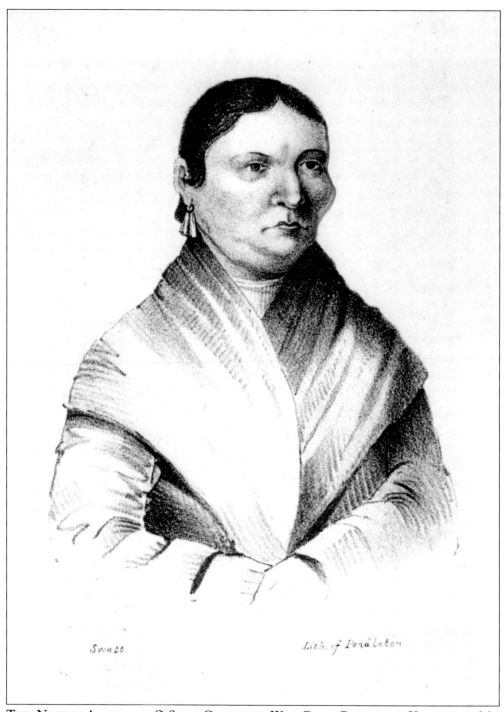

Swett. Lith. of Pendleton

THE NATIVE AMERICAN, O-SHAU-GUSCODAY WAY-GUO, COMMONLY KNOWN AS MS. JOHNSON. Ms. Johnson and her European husband were inhabitants of Sault Ste. Marie in the early 1800s, and provided valuable information about the landscape to early explorers. Her daughter, Jane Johnson, married explorer and Indian Agent Henry Rowe Schoolcraft. (From *Sketches of a Tour to the Lakes*, by Thomas L. McKenney, 1827.)

NATIVE-AMERICAN GRAVES. Native-American graves were common sightings along the Lake Superior shores in the first half of the 19th century, adding much to the romantic lure of the region. Sadly, the looting of these graves by European and American travelers was also a common practice. (From *Sketches of a Tour to the Lakes*, by Thomas L. McKenney, 1827.)

SKETCH OF A SKELETON OF A CHIPPEWA LODGE. The mobile Native Americans in the region often lived in different locations seasonally and would frequently return to the quarters they had temporarily left. (From *Sketches of a Tour to the Lakes*, by Thomas L. McKenney, 1827.)

THOMAS MCKENNEY. Thomas McKenney led an expedition from Sault Ste. Marie to Fond du Lac in 1826 accompanied by Lewis Cass, H.R. Schoolcraft, and at least 60 other men. Instead of canoes, which were the mode of transportation for the earlier 1820 expedition, this expedition was undertaken in "barges," which were probably similar to mackinaw boats. McKenney subsequently wrote of his travels in a publication called *Tour of the Lakes*, which was printed in 1827. (From the Collection of the Marquette County Historical Society.)

16

KEY-WAY-NO-WUT, OR GOING CLOUD, A WAR CHIEF NEAR FOND DU LAC THAT MCKENNEY CAME INTO CONTACT WITH ON THE 1826 EXPEDITION. Going Cloud was the leader of a band that was accused of having killed two Americans. McKenney gave Going Cloud a stern warning for these actions, but thought him to be personally innocent of the murders. (From *Sketches of a Tour to the Lakes*, by Thomas L. McKenney, 1827.)

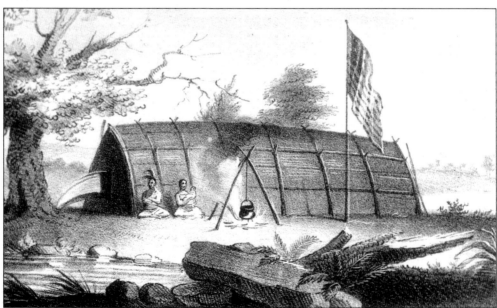

CHIPPEWA LODGE. This is a sketch of a lodge McKenney entered on his voyage in order to relay a message to one of its 12 to 14 inhabitants. McKenney found this group to be hospitable. As he mentioned he dropped his sketching pencil on his departure from the lodge, it was promptly returned to him. (From *Sketches of a Tour to the Lakes*, by Thomas L. McKenney, 1827.)

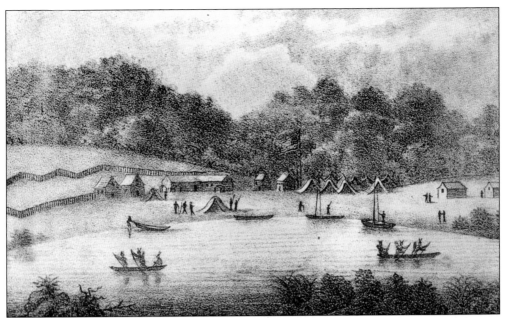

THE DESTINATION OF MCKENNEY'S VOYAGE, THE AMERICAN FUR COMPANY AT FOND DU LAC. McKenney took part in treaty negotiations with the Native Americans there in 1826. (From *Sketches of a Tour to the Lakes*, by Thomas L. McKenney, 1827.)

THE AMERICAN FUR COMPANY, FOND DU LAC. This is another sketch of the American Fur Company at Fond du Lac, depicting the Native Americans and American fur traders living on opposite sides of the river. The walls of the fort suggest a life of protection and fear. (From *Sketches of a Tour to the Lakes*, by Thomas L. McKenney, 1827.)

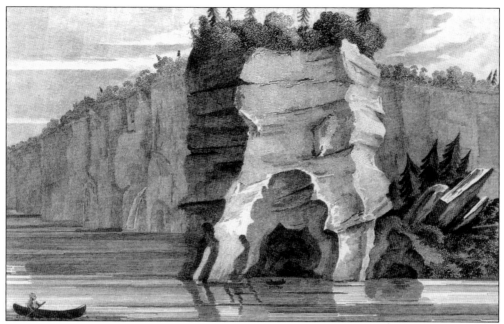

"Cave Rock." This is a formation in the Pictured Rocks Thomas McKenney called "cave rock." A pile of ruins from a collapsed structure is noticeable on the right. Noticing the "threatening posture" of the rock formation, McKenney did not venture too close in fear of another collapse. (From *Sketches of a Tour to the Lakes*, by Thomas L. McKenney, 1827.)

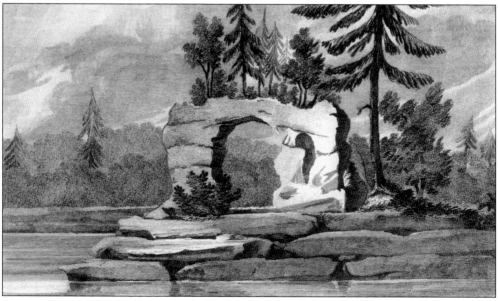

Doric Rock, Pictured Rocks. Virtually everyone, from explorers to latter-day pleasure travelers, were impressed with the distinction and beauty of the Pictured Rocks on Lake Superior. From the east, the Doric Rock is the first structure to be seen. McKenney claimed this structure "seems to have been sent in advance to announce to the voyageur the surprising and appalling grandeur which awaits him ahead." (From *Sketches of a Tour to the Lakes*, by Thomas L. McKenney, 1827.)

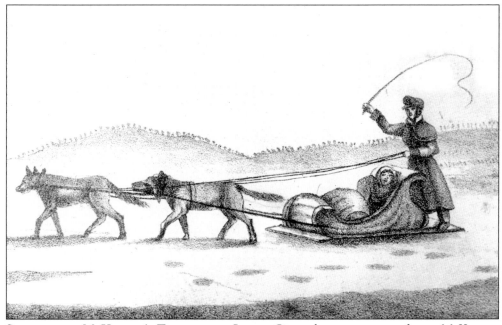

SKETCH FROM MCKENNEY'S TOUR OF THE LAKES. Given the vast amount of snow McKenney had heard fell in the Upper Peninsula, he claimed "it is no wonder that in such a country, people, who go out at all, have to resort to dog trains or snow shoes." (From *Sketches of a Tour to the Lakes*, by Thomas L. McKenney, 1827.)

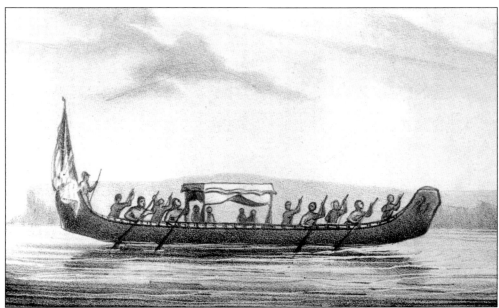

CANOE. Large canoes such as this sketch from McKenney's tour of the lakes were impressive structures. Despite being made of bark, some were capable of carrying 2,000 pounds. (From *Sketches of a Tour to the Lakes*, by Thomas L. McKenney, 1827.)

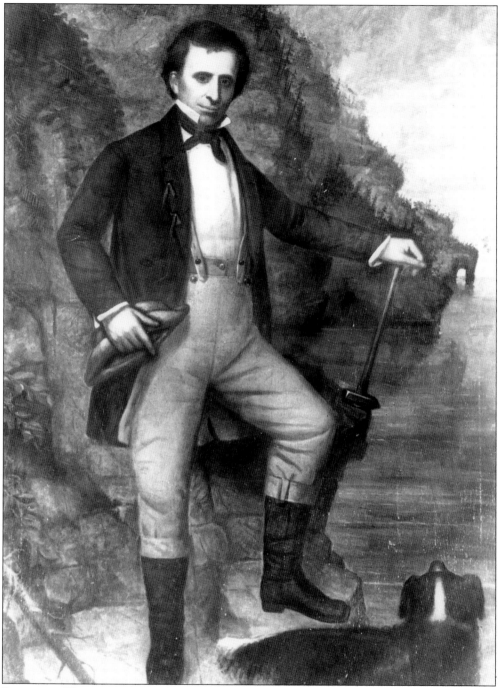

DOUGLASS HOUGHTON. Houghton got a glimpse of the life of an explorer on Schoolcraft's 1832 expedition, where he served as surgeon, botanist, and geologist for the party. He was later involved in surveying portions of the Upper Peninsula and his 1841 published report, which detailed masses of pure copper on the Keweenaw Peninsula, led to the development of the copper mines in that area. Houghton drowned in an accident on Lake Superior in 1845. (From the Collection of the Marquette County Historical Society.)

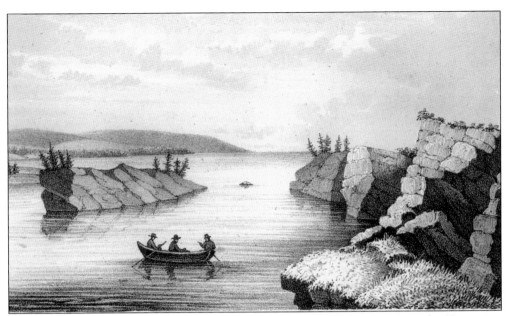

HORSE-SHOE HARBOR, NEAR COPPER HARBOR. The existence of copper at the Keweenaw Peninsula had been known for some time before the 1820 expedition, but the area, according to Henry Rowe Schoolcraft in a letter to Secretary of War John C. Calhoun, was "in the centre of a region characterized by its wild, rugged, and forbidding appearance." After Douglass Houghton's report in the 1840s, however, mining operations took hold in the region. (From *Report on the Geology of the Lake Superior Land District, Part I: Copper Lands*, by J.W. Foster and J.D. Whitney, 1850.)

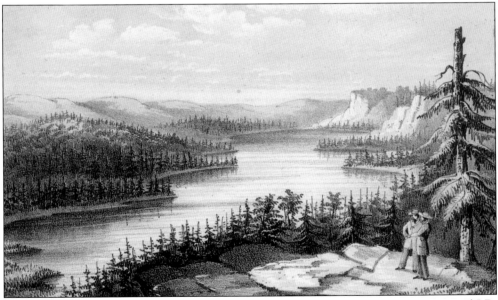

SKETCH OF CARP LAKE IN THE PORCUPINE MOUNTAINS. The geologists J.W. Foster and J.D. Whitney's incorporated this sketch as part of their influential publication on the geology of the Lake Superior region in 1850. (From *Report on the Geology of the Lake Superior Land District, Part I: Copper Lands*. J.W. Foster and J.D. Whitney, 1850.)

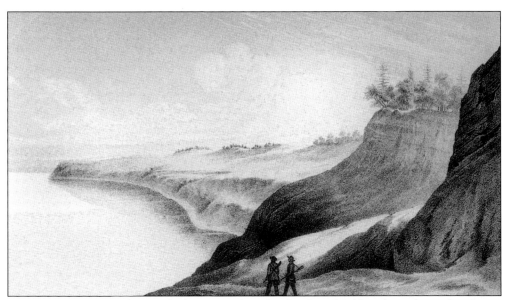

THE GRAND SABLE. Along with the Pictured Rocks, the Grand Sable, a huge dune of sand near Grand Marais, was one of the most common land features described by explorers. The French fur trader Pierre Esprit Radisson described its presence as early as 1658. (From *Report on the Geology of the Lake Superior Land District, Part II*, by J.W. Foster and J.D. Whitney, 1851.)

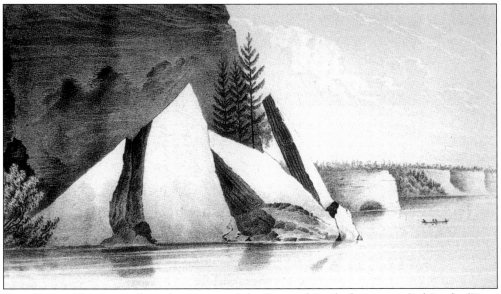

SAIL ROCK. This is a collapsed structure of the Pictured Rocks known as Sail Rock. (From *Report on the Geology of the Lake Superior Land District, Part II*, by J.W. Foster and J.D. Whitney, 1851.)

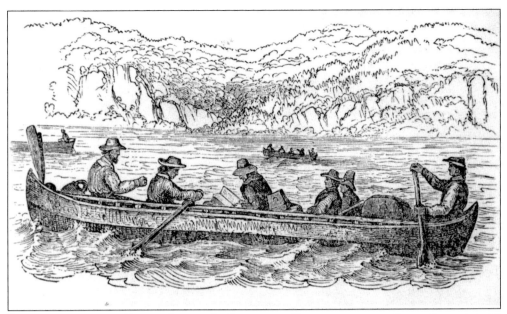

ILLUSTRATION FROM LOUIS AGASSIZ'S SCIENTIFIC PUBLICATION ON LAKE SUPERIOR IN 1850. In the 1840s and '50s, explorers often called themselves "scientific gentlemen," who described the landscape in terms of its geology and flora and fauna. (From *Lake Superior: Its Physical Character, Vegetation, and Animals*, by Louis Agassiz, 1850.)

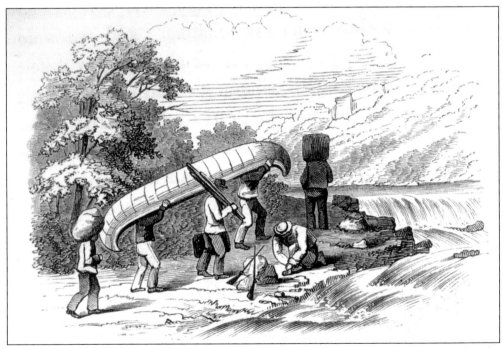

PORTAGING. Portaging was a common nuisance for explorers and early travelers. Traveling by water to Lake Superior itself often required a portage, since before the lock at Sault Ste. Marie was built, the only way to enter the lake from Lake Huron was through forceful rapids. (From *Minnesota and the Far West*, by Laurence Oliphant, 1855.)

COPPER HARBOR. Copper Harbor, seen from Lake Superior in the early phases of its development, was certainly a welcoming sight to the copper miners that journeyed to the Keweenaw Peninsula in increasing numbers during the 1840s. (From *Harper's Magazine*, March 1853.)

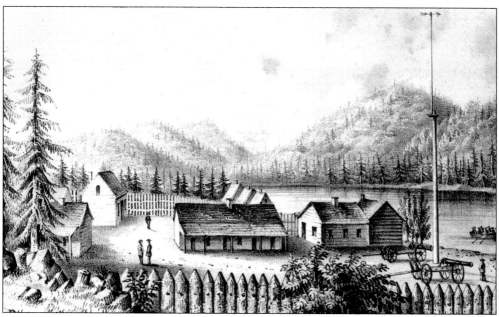

FORT WILKINS. Fort Wilkins was established in 1845, near Copper Harbor, to protect American settlers from what they perceived to be danger from hostile Native Americans. (From *Report on the Geology of the Lake Superior Land District, Part I: Copper Lands.* J.W. Foster and J.D. Whitney, 1850.)

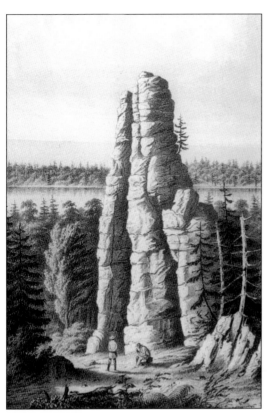

MONUMENT ROCK, ISLE ROYALE.
Tradition has it that Benjamin Franklin purposefully drew a boundary line north of Isle Royale to include it as a part of the United States during the Treaty of Paris negotiations in 1783, since he knew of the copper bearing rocks of the region and recognized the potential for mining it. (From *Report on the Geology of the Lake Superior Land District, Part II*, by J.W. Foster and J.D. Whitney, 1851.)

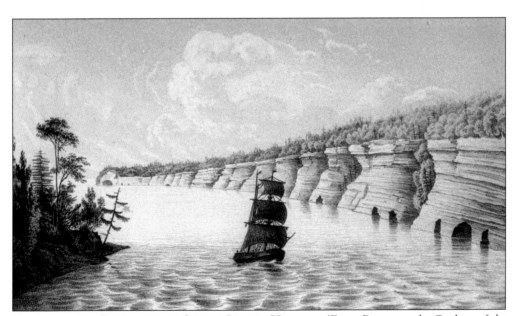

SKETCH OF THE ENTRANCE OF GRAND ISLAND HARBOR. (From *Report on the Geology of the Lake Superior Land District, Part II*, by J.W. Foster and J.D. Whitney, 1851.)

PICTURED ROCKS. Two Native-American guides and two American travelers view "the Castles," a formation of the Pictured Rocks. (From *Report on the Geology of the Lake Superior Land District, Part II,* by J.W. Foster and J.D. Whitney, 1851.)

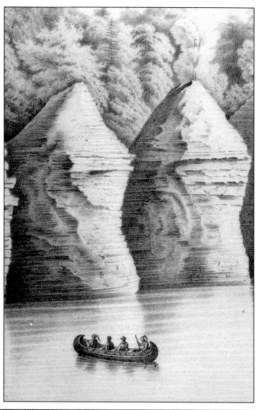

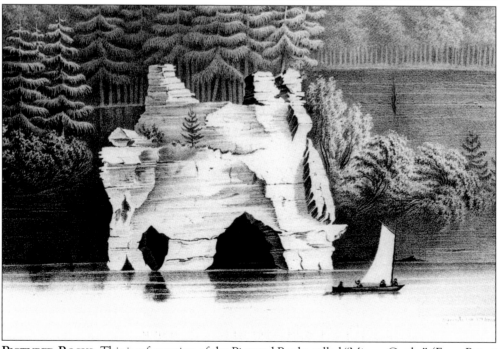

PICTURED ROCKS. This is a formation of the Pictured Rocks called "Miners Castle." (From *Report on the Geology of the Lake Superior Land District, Part II,* by J.W. Foster and J.D. Whitney, 1851.)

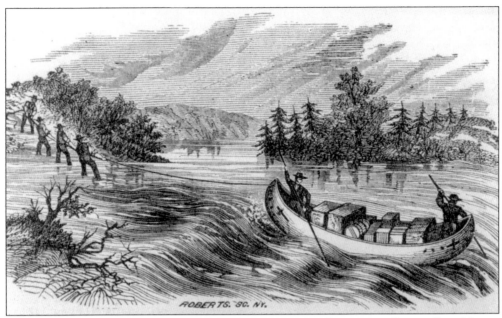

PULLING UP AN APPARENT MISSIONARY CANOE AT THE RAPIDS OF SAULT STE. MARIE.
Missionaries were also common travelers to Lake Superior, perhaps most famously was Bishop
Frederic Baraga. (From *Sailing On the Great Lakes and Rivers of America*, by J. Disturnell, 1874.)

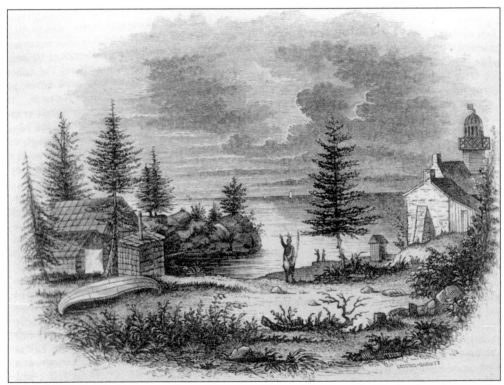

SKETCH OF A LIGHTHOUSE AND BARK HOUSE AT EAGLE HARBOR. The Native American on the
beach appears to be scanning the horizon for distant ships. (From *Harper's Magazine*, March 1853.)

A FISHERMAN AT TRAP ROCK RIVER.
(From *Report on the Geology of the Lake Superior Land District, Part II*, by J.W. Foster and J.D. Whitney, 1851.)

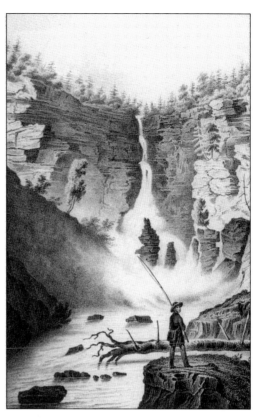

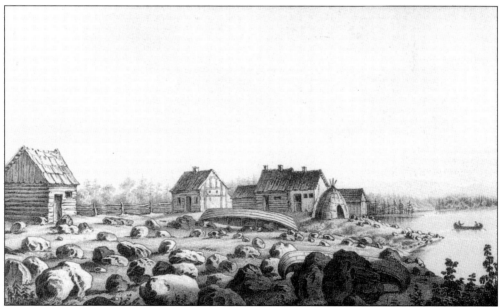

SKETCH OF SAULT STE. MARIE, WHERE LARGE BOULDERS DOTTED THE LANDSCAPE. A European woman traveler noted in 1853, that "on this point, covered with large boulders, there is a small cluster of Chippewa wigwams, the occupants of which live by fishing." (From *Report on the Geology of the Lake Superior Land District, Part II*, by J.W. Foster and J.D. Whitney, 1851.)

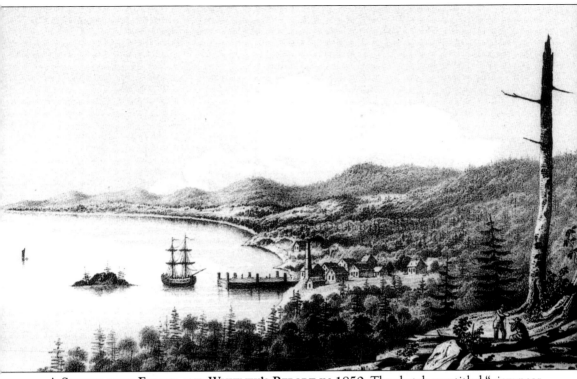

A Sketch from Foster and Whitney's Report in 1850. The sketch was titled "view near Carp River, Lake Superior." Afterwards, this location would grow to be the largest city in the Upper Peninsula, Marquette. (From *Report on the Geology of the Lake Superior Land District, Part II*, by J.W. Foster and J.D. Whitney, 1851.)

Two
LITERARY TRAVELERS
1830s–1900

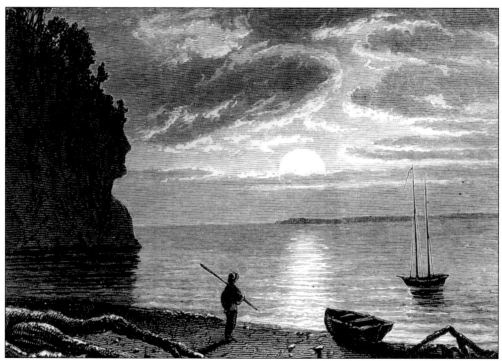

"LITERARY TRAVELERS." Literary Travelers are generally categorized as individuals in search of the picturesque or sublime. Unlike explorers, they traveled to the Lake Superior Region for a certain wilderness experience, not to acquire or survey land or gather scientific data. Along with destinations such as Niagara Falls and the Adirondack region, Lake Superior was a popular area in which to experience the picturesque. This illustration is by William Hart. (From *Picturesque America*, Vol. 1, Edited by William Cullen Bryant, 1872.)

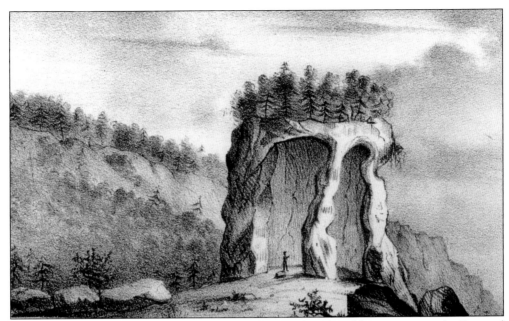

"La Chappelle." This is a view of "La Chappelle" or "the Chapel," a structure in the Pictured Rocks so named because it resembles a church. (From *Life on the Lakes: Being Tales and Sketches Collected During a Trip to the Pictured Rocks of Lake Superior*, Vol. 1, by Chandler Robbins Gilman, 1836.)

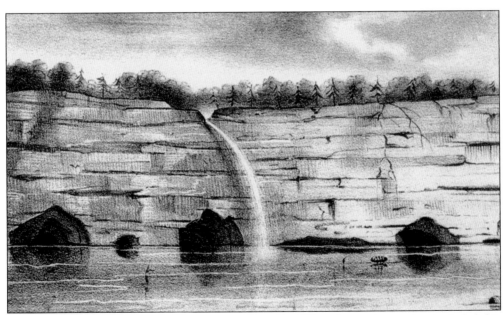

Chandler Gilman's Travel Narrative. Chandler Gilman's travel narrative included this sketch, depicting one of many picturesque waterfalls of the Pictured Rocks. Gilman was one of the first travelers to visit the region strictly for pleasure; he made the trip in 1835. (From *Life on the Lakes: Being Tales and Sketches Collected During a Trip to the Pictured Rocks of Lake Superior*, Vol. 2., by Chandler Robbins Gilman, 1836.)

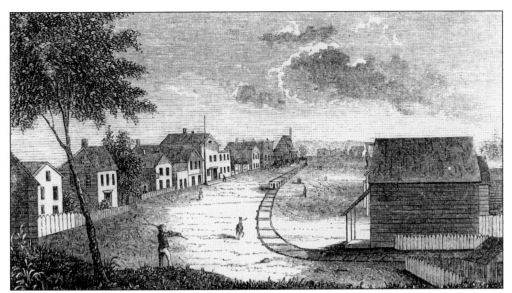

SKETCH OF A STREET IN SAULT STE. MARIE. Almost all waterborne travelers to Lake Superior stopped in Sault Ste. Marie, making it one of the most described places in 19th-century travel narratives to the Lake Superior region. When William Cullen Bryant visited Sault Ste. Marie in 1846, he even recognized two businessmen from New York. (From *Harper's Magazine*, March 1853.)

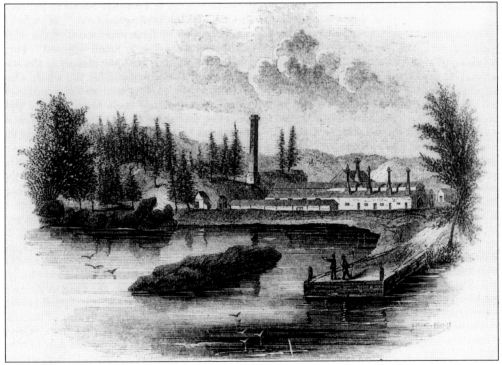

SKETCH OF EARLY MARQUETTE. Marquette, depicted in an early 1850s sketch, as the town was struggling to its feet at the dawn of the iron mining operations. (From *Harper's Magazine*, March 1853.)

SAFE HARBOR. Chapel Beach was one of the few safe places to land a small boat along the rugged 15-mile shoreline of the Pictured Rocks. (From the Collection of Jack Deo.)

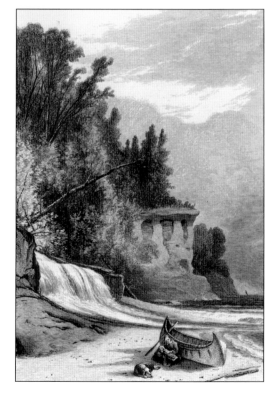

ROMANTIC LURE. This is an artist's depiction of the Chapel and Chapel Beach that appeared in the 1872 edition of *Picturesque America.* The apparent Native American, her child, and a sleeping dog visually add to the romantic lure of the Pictured Rocks. William Hart illustrated this sketch. (From *Picturesque America*, Vol. 1, Edited by William Cullen Bryant, 1872.)

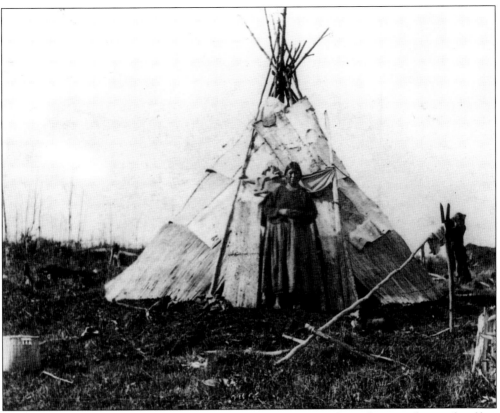

SAULT STE. MARIE, EARLY 1870S. A Chippewa woman poses for a photograph outside of her dwelling near Sault Ste. Marie in the 1870s. (From the Collection of Jack Deo.)

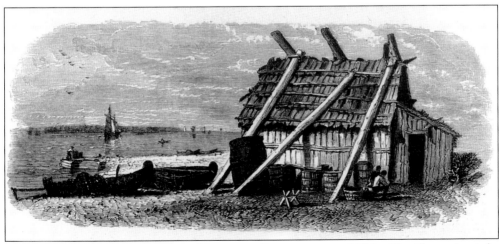

SKETCH OF AN "INDIAN HUT" ON MACKINAC ISLAND IN THE 1870S. The illustration is by William Hart. (From *Picturesque America*, Vol. 1, Edited by William Cullen Bryant, 1872.)

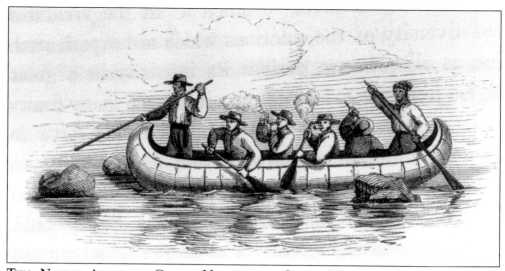

Two Native American Guides Navigate a Canoe With European Occupants Through Rocky Waters. Smoking pipes was a very common practice among travelers. Charles Lanman, who traversed Lake Superior in 1846, noted "a 'pipe,' is what a sporting gentlemen might call a heat of six miles, at the end of which our oarsmen would rest themselves, while enjoying a smoke of ten minutes." (From *Minnesota and the Far West*, by Laurence Oliphant, 1855.)

An "Indian Packer." Traveling to the Lake Superior region for recreation before regular steamer or railroad lines were established was an expensive venture. Guides and canoes had to be secured at places like Sault Ste. Marie for a voyage into the lake. Chandler Gilman, one of the first tourists to the region, claimed in 1836 that his guides were "hired at 75 cents per day and voyageurs rations…for this they engage to go with us into the lake as far as we choose." (From *Harper's Magazine*, 1881-1882.)

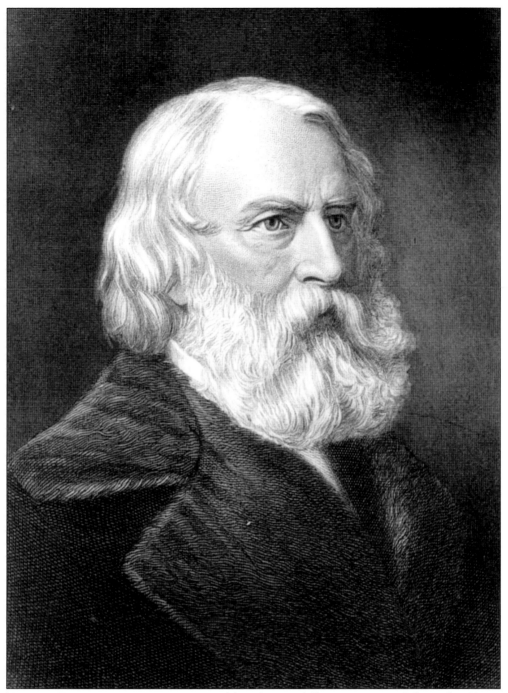

HENRY WADSWORTH LONGFELLOW. Although Longfellow never traveled to the Upper Peninsula, his epic poem, "The Song of Hiawatha," played a large role in making the Lake Superior Region a famous and romantic retreat for travelers. Its influence still lingers today, as Lake Superior historian Grace Lee Nute once exclaimed, "ask even a semiliterate what Gitchee Goomee refers to, and he will reply 'Lake Superior.'" (From *Life of Henry Wadsworth Longfellow,* edited by Samuel Longfellow, 1886.)

CONTEMPLATION. An individual in contemplation is captured in drawing, on the shores of Lake Superior, near the waterfall called the Silver Cascade in the Pictured Rocks. The illustration is by William Hart. (From *Picturesque America*, Vol. 1, Edited by William Cullen Bryant, 1872.)

A CLOSE UP OF A SUBLIME SCENE ON CHAPEL BEACH, PICTURED ROCKS. Constance Woolson, a relative of James Fenimore Cooper and frequent inhabitant of Mackinac Island, wrote Chapel Beach was at one time a place where "Indians performed rites to appease" a "grand god of the storm." The illustration is by William Hart. (From *Picturesque America*, Vol. 1, Edited by William Cullen Bryant, 1872.)

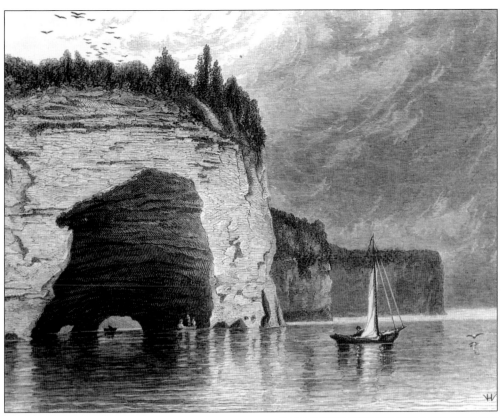

SPECTATORS LEISURELY EXAMINE THE GRAND PORTAL OF THE PICTURED ROCKS. A portion of Grand Portal point has since collapsed due to wave action. This illustration is by William Hart. (From *Picturesque America*, Vol. 1, Edited by William Cullen Bryant, 1872.)

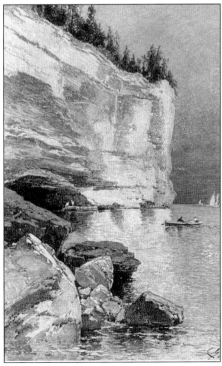

THE GRAND ARCH OF THE PICTURED ROCKS. (From *Harper's Magazine*, December 1891–May 1892.)

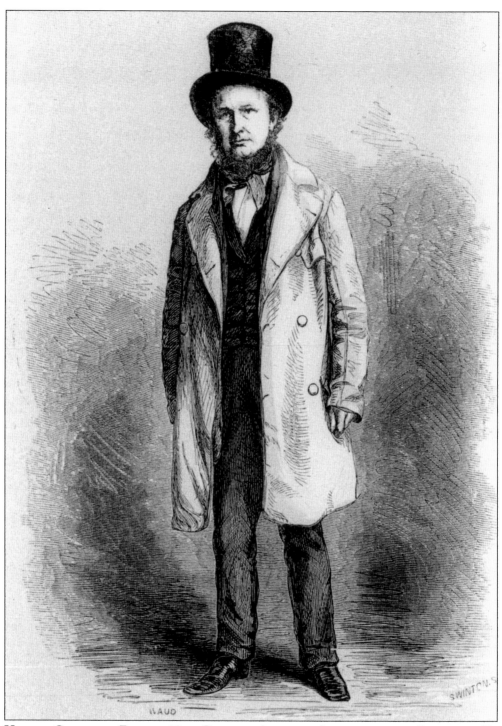

HORACE GREELEY, A FAMOUS 19TH-CENTURY AMERICAN JOURNALIST AND REFORMER. He invested in the Lake Superior copper mines, and took two trips to the Keweenaw Peninsula in the late 1840s to inspect the fruits of his investments. (From *The Life of Horace Greeley*, by J. Parton, 1855.)

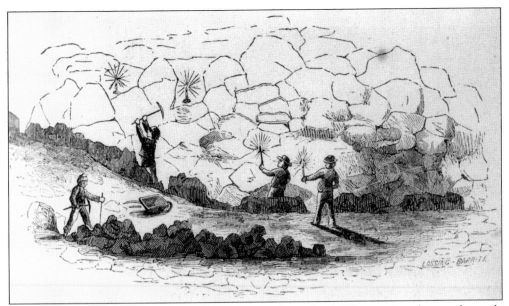

COPPER MINES. When the copper mines opened in the 1840s, tourists frequently made the mines stopping points on their Lake Superior voyage. One traveler noted of the copper operations: "showers of sparks, streams of molten metal, and green and blue blazes fill the fore and background to the dismay of curious visitors" (*Harper's Magazine*, March 1853.)

THE MINING FRONTIER. Detailed sketches of the mining frontier, such as the "stamps" shown here, were relayed to major publications such as *Harper's Magazine* by adventurous correspondents for publication. (From *Harper's Magazine*, March 1853.)

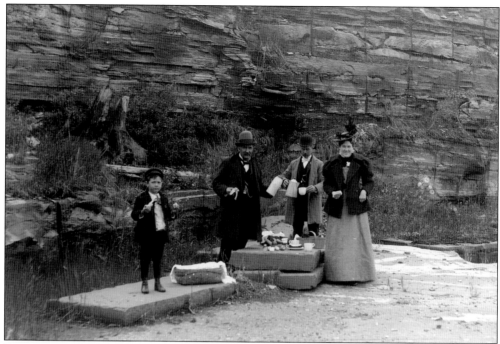

PICNICKING, LATE 1800S. Tourists in the late 1800s picnic near a sandstone quarry close to Lake Linden. (From the Collection of Jack Deo.)

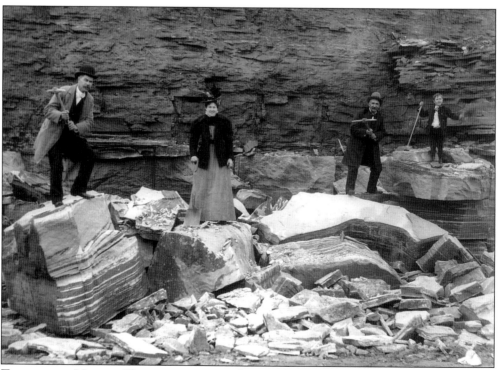

TOURISTS AS MINERS. The same tourists as above pick up pick axes at a sandstone quarry for the camera for a good laugh. (From the Collection of Jack Deo.)

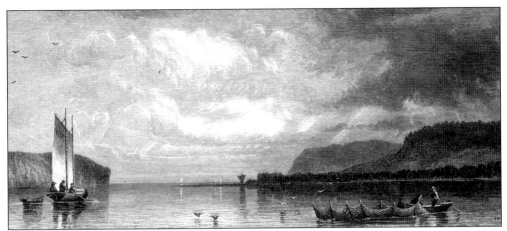

MUNISING HARBOR. One 19th-century traveler claimed the harbor is "not only beautiful in a high degree, but, as the artist who drew its picture expressed himself, 'it rests you just to look at it.'" Illustrated by William Hart. (From *Picturesque America*, Vol. 1, Edited by William Cullen Bryant, 1872.)

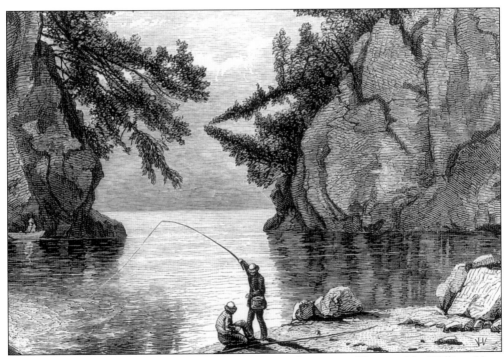

FISHERMAN FIND A QUIET FISHING HOLE ON LAKE SUPERIOR. Illustrated by William Hart. (From *Picturesque America*, Vol. 1, Edited by William Cullen Bryant, 1872.)

HARPER'S
NEW MONTHLY MAGAZINE.

No. CCIV.—MAY, 1867.—Vol. XXXIV.

THE PICTURED ROCKS OF LAKE SUPERIOR.

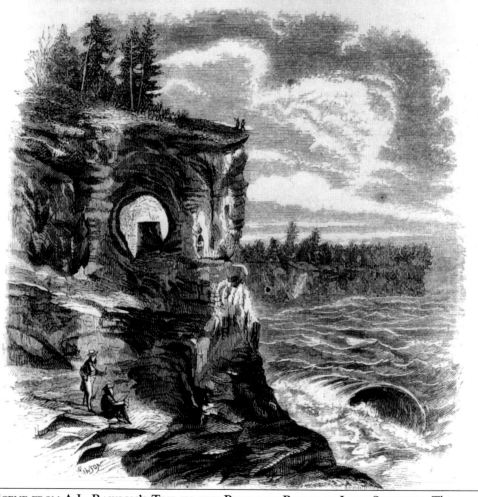

SCENE FROM A.L. RAWSON'S TRIP TO THE PICTURED ROCKS OF LAKE SUPERIOR. This scene appeared on the cover of *Harper's Magazine* in 1867. The *Harper's* correspondent enjoyed his picturesque voyage through the Lake Superior region. He also intrigued a local resident of the Upper Peninsula who saw Rawson's sketches of the landscape and desired to learn his trade. (From *Harper's Magazine*, May 1867.)

Bill Lemm. A.L. Rawson's guide Bill Lemm of Grand Island, who among other things, provided Rawson with a comfortable bed. Rawson was apparently delighted with the accommodation, as he exclaimed "how glorious it is to sleep in the country!" (From *Harper's Magazine*, May 1867.)

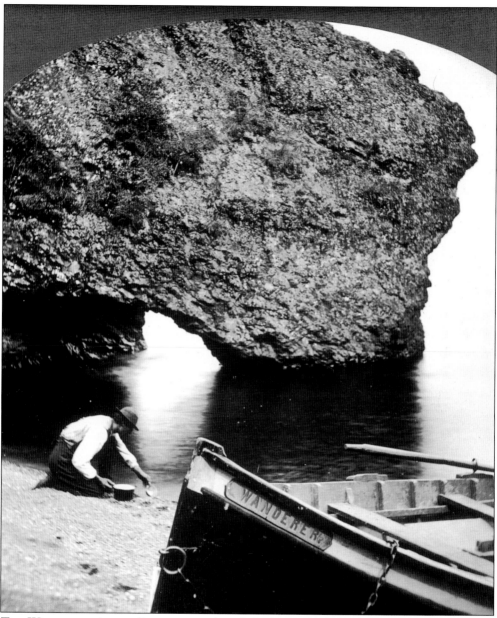

The Wanderer. A man dips out water from Lake Superior alongside his boat, *The Wanderer*. (From the Collection of Jack Deo.)

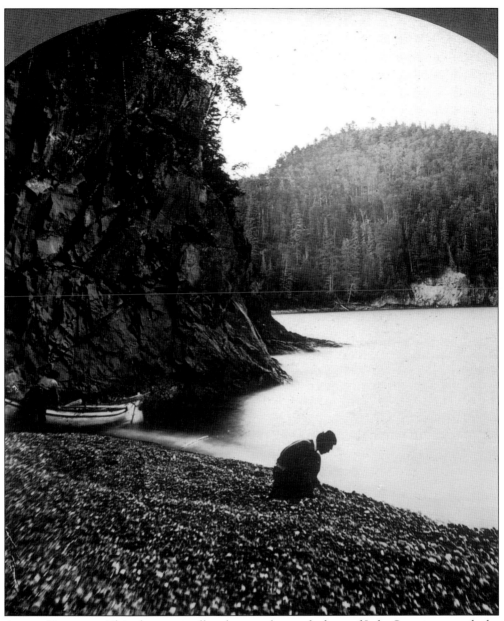

AGATE HUNTING. This photo, actually taken on the north shore of Lake Superior, reveals the amusement of agate hunting. As early as 1846, a guide to the Lake Superior region claimed this to be "the most fascinating and bewildering yet certainly innocent amusement." (From the Collection of Jack Deo.)

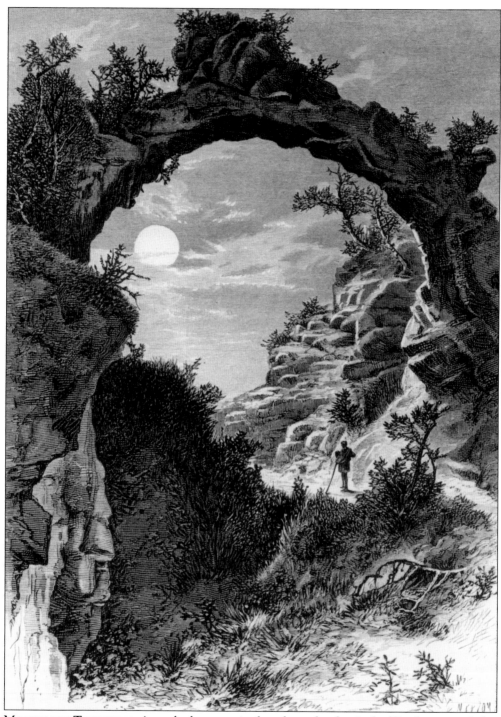

MOONLIGHT THOUGHTS. An onlooker stops in thought under the Arched Rock at moonlight. The illustration is by William Hart. (From *Picturesque America*, Vol. 1, Edited by William Cullen Bryant, 1872.)

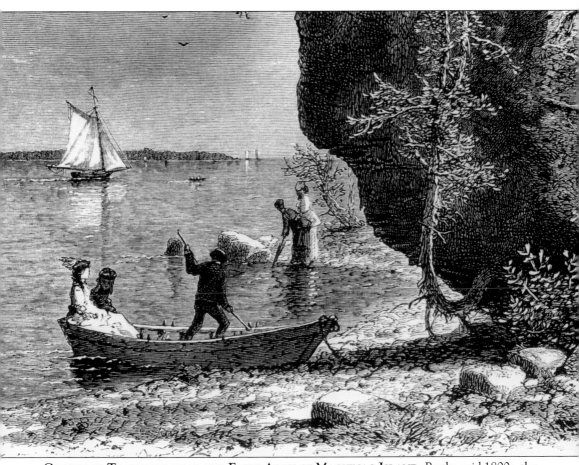

GROUPS OF TRAVELERS NEAR THE FAIRY ARCH OF MACKINAC ISLAND. By the mid 1800s, the island had become a fashionable resort area. One traveler noted as early as 1846 that "during the season of navigation, [Mackinac Island] is one of the busiest little places in the world." Illustrated by William Hart. (From *Picturesque America*, Vol. 1, Edited by William Cullen Bryant, 1872.)

A Horse and Buggy Promenade near the Shores of Mackinac Island. To the right are canoes with Native Americans, apparently selling items that interest curious tourists. Godfrey T. Vigne, who traveled to Sault Ste. Marie with the famous Alexis de Tocqueville in the early 1830s, noted: "Mackinac is excellent for Indian curiosities." (From *Island of Mackinac*, by J. Disturnell, 1875.)

An 1860s Photo of Mackinac Island from the Beach. Fort Mackinac looms in the background. (From the Collection of Jack Deo.)

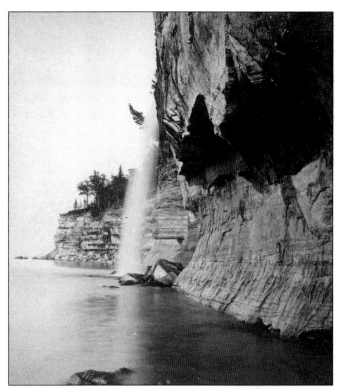

A WATERFALL IN THE PICTURED ROCKS. The photo is by B.F. Childs. (From the Collection of Jack Deo.)

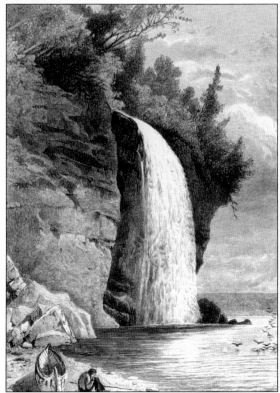

THE SILVER CASCADE IN THE PICTURED ROCKS, AS ILLUSTRATED BY WILLIAM HART. (From *Picturesque America*, Vol. 1, Edited by William Cullen Bryant, 1872.)

A Mackinaw Boat Sails near an Unknown Location on Lake Superior. Mackinaw boats were an ideal form of transportation for pleasure travelers, as they provided more safety than a smaller canoe, yet were often small enough to be beached on shore. (From the Collection of Jack Deo.)

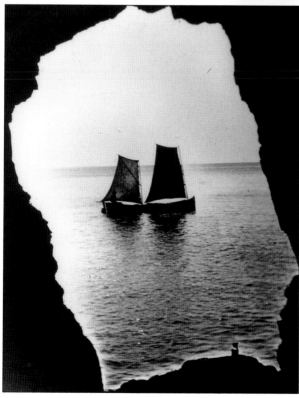

A Mackinaw Boat, as Seen Through an Arch on the Apostle Islands in the 1870s. (From the Collection of Jack Deo.)

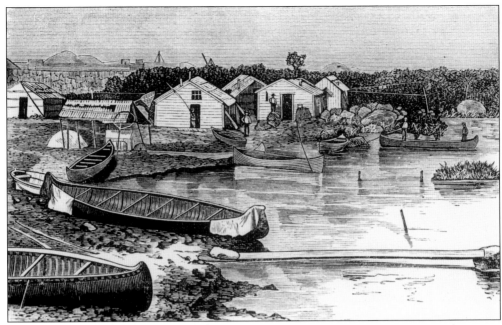

Sketch of Sault Ste. Marie from a Travel Guide to Lake Superior in 1874. The canoes belong to the Chippewa fishermen, who frequently fished the cascading river for its abundant supply fish. (From *Sailing On the Great Lakes and Rivers of America*, by J. Disturnell, 1874.)

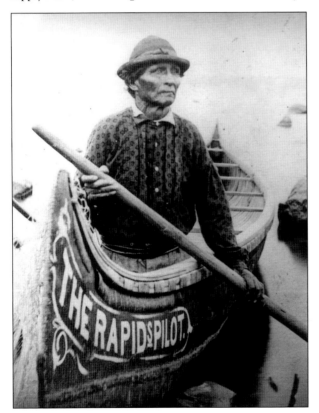

Photo of a Chippewa Rapids Pilot. Julian Ralph, a frequent traveling companion of Frederic Remington, traveled to Sault Ste. Marie and claimed "these Indian boatmen derive their income by renting their canoes and their own skillful services toward the sport of shooting the rapids." (From the Collection of Jack Deo.)

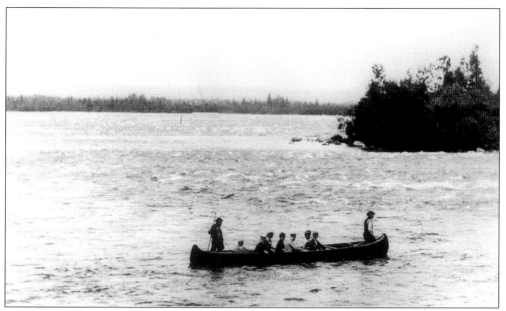

A GROUP OF TOURISTS READY TO "SHOOT THE RAPIDS." Since at least the 1830s, travelers to Sault Ste. Marie braved the rapids for adventure in canoes guided by Native Americans. Charles Lanman, an angler and amateur explorer admitted in 1846 that it took him "three days to muster up sufficient courage to go down these rapids." (From the Collection of Jack Deo.)

PHOTO OF A CANOE BUILDER AT SAULT STE. MARIE IN THE 1870S. Canoe building and repairing no doubt had a good financial market near Sault Ste. Marie throughout the 1800s. (From the Collection of Jack Deo.)

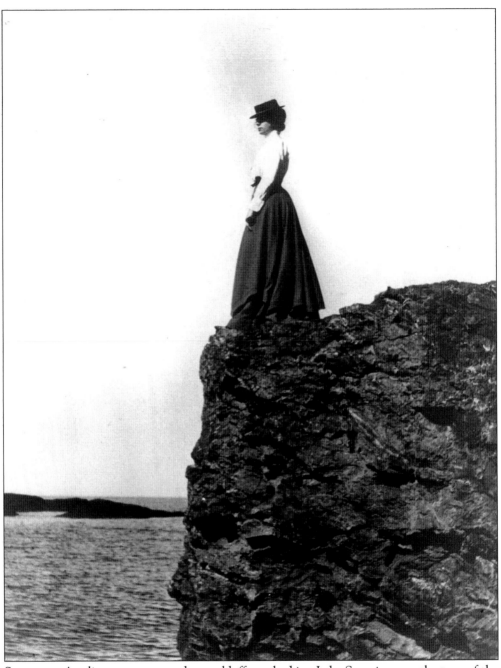

SOLITUDE. A solitary woman stands on a bluff overlooking Lake Superior near the turn of the century. (From the Collection of Jack Deo.)

Three

STEAMERS AND THE GROWTH OF TOURISM
1855–1870s

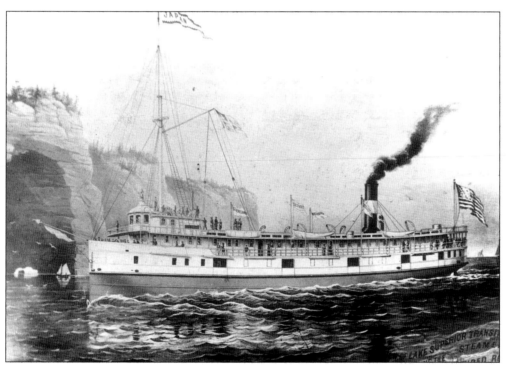

THE STEAMER JAPAN TOURING THE PICTURED ROCKS. The *Japan*, along with the sister ships *India* and *China*, were popular Lake Superior vessels built by Edwin Townsend Evans in the 1870s. When the canal at Sault Ste. Marie was completed in 1855, steamer lines began to tout their new ability to travel directly to Lake Superior from the rest of the Great Lakes chain. The lock at Sault Ste. Marie opened the door for the growth of tourism on Lake Superior because the continuous steamer lines provided more structure to travel and a trip was less costly without having to rent boats or guides to explore the Lake Superior region. (From the Collection of the Marquette County Historical Society.)

THE DOCK AT SAULT STE. MARIE A FEW YEARS BEFORE THE LOCK WAS BUILT. Robert Clarke, who traveled to Copper Harbor in 1852, had to wait a couple of days at Sault Ste. Marie after his steamer from Lake Huron docked, until the steamer *Baltimore* arrived from another location on Lake Superior. (From *Harper's Magazine*, March 1853.)

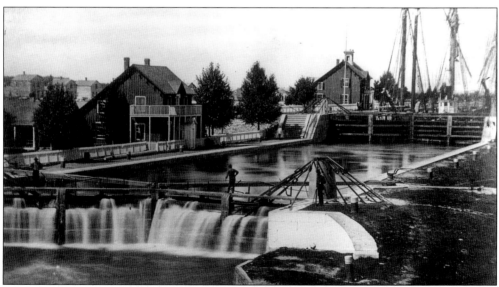

ENTRANCE TO THE LOCK AT SAULT STE. MARIE. Laurence Oliphant, who traveled to the region just after the canal was completed, noted: "now that the canal at Sault Ste. Marie is finished, which connects Lake Superior with Lakes Michigan and Huron, there is nothing to prevent a yacht, not drawing more than eight feet of water, sailing from Liverpool to Fond du Lac." (From the Collection of Jack Deo.)

ADVERTISEMENTS FOR THE MISSION HOUSE AND THE CHIPPEWA HOUSE AT SAULT STE. MARIE, FROM A GUIDE BOOK TO LAKE SUPERIOR IN THE 1870S. They often boasted of their proximity to fishing grounds and a fresh supply of whitefish. (From *Sailing On the Great Lakes and Rivers of America*, by J. Disturnell, 1874.)

THE CHIPPEWA HOUSE AT SAULT STE. MARIE. Robert Barnwell Roosevelt, uncle of Theodore Roosevelt, and an avid angler, said of this house in 1865, that it was Sault Ste. Marie's "principal hotel," and is "admirably kept, and doubtless the pioneer of an infinitely more gorgeous affair." (From the Collection of Jack Deo.)

MISSION HOUSE,

MACKINAC, MICH.,

E. A. FRANKS, Proprietor.

This old and favorite Hotel is most delightfully situated on the romantic ISLAND OF MACKINAC, within a short distance of the water's edge, and contiguous to the Arched Rock, Sugar Loaf, and other Natural Curiosities in which this famed Island abounds; being alike celebrated for its pure air, romantic scenery, and fishing grounds.

MACKINAC, *July*, 1874.

CHIPPEWA HOUSE,

SAUT STE MARIE,

MICHIGAN.

This favorite Hotel is pleasantly situated, near the Steamboat Landings, at the mouth of the Ship Canal, and in the immediate vicinity of Fort Brady.

No section of country exceeds the SAUT and its vicinity for

Fishing, Hunting, or Aquatic Sports.

The table of the Hotel is daily supplied with delightful White Fish, and other varieties of the season, no pains being spared to make this house a comfortable home for the pleasure-traveler or man of business.

276 H. P. SMITH, Proprietor

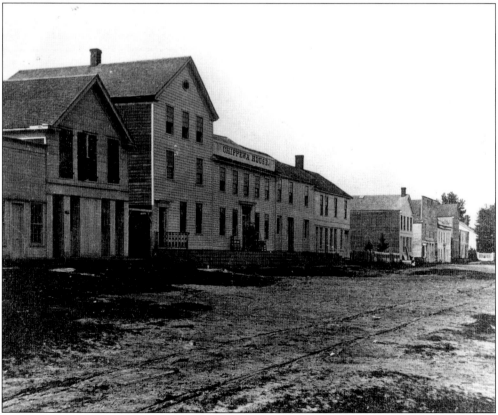

ISLAND HOUSE,

MACKINAC, MICHIGAN.

Capt. H. VAN ALLEN, Proprietor.

This favorite HOTEL is pleasantly situated, facing the Harbor, where there is a fine beach, and near the Steamboat Landing. In the rear of the House are high grounds, where stands old FORT MACKINAC, overlooking the beautiful Straits of Mackinac and several picturesque Islands.

THE ISLAND HOUSE. This advertisement for the Island House on Mackinac Island boasted of its proximity to "a fine beach" and the steamboat landing. (From *Island of Mackinac*, by J. Disturnell, 1875.)

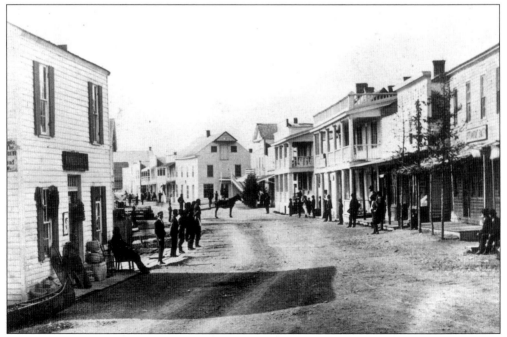

MAIN STREET OF MACKINAC ISLAND IN THE 1860S. Mackinac Island was a bustling place for travelers in the 1800s, as well as today. (From the Collection of Jack Deo.)

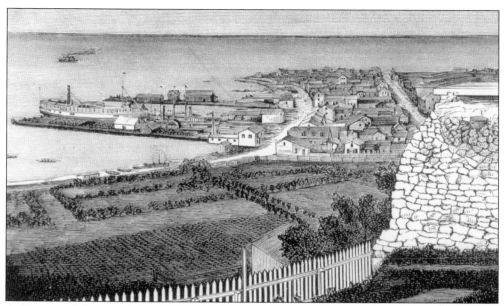

A VIEW OF MACKINAC ISLAND FROM NEAR THE FORT. A variety of ships are depicted as coming and going from the busy island. (From *Island of Mackinac*, by J. Disturnell, 1875.)

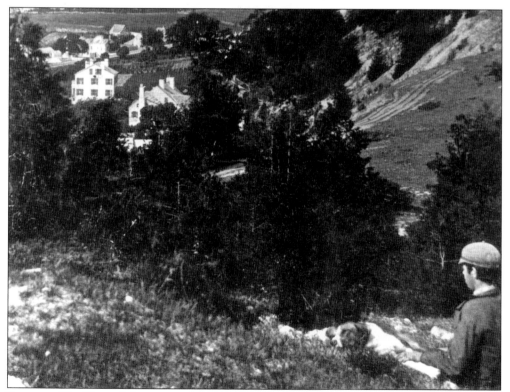

BOY AND HIS DOG. A boy sits with a sleeping dog on a bluff at Mackinac Island, probably on the look out for incoming ships. (From the Collection of Jack Deo.)

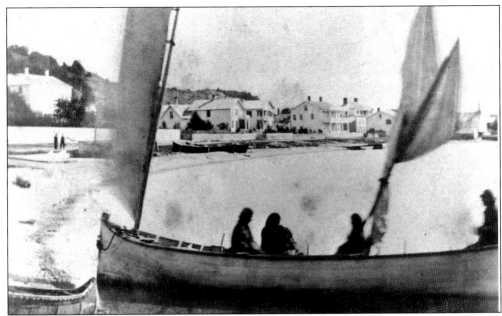

A BEACHED MACKINAW BOAT AT MACKINAC ISLAND. (From the Collection of Jack Deo.)

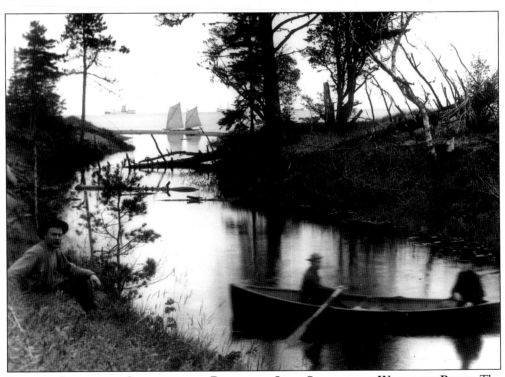

BOATS OF INCREASING SIZES FROM THE RIVER INTO LAKE SUPERIOR AT WHITEFISH POINT. The journey from Whitefish Point westward along the cliffs of the Pictured Rocks on Lake Superior was a dangerous undertaking, as one guidebook warned: "in all navigation on Lake Superior, there is none more dreaded by the mariner than from Whitefish Point to Grand Island…there is not a single place where a landing can be made." (From the Collection of Jack Deo)

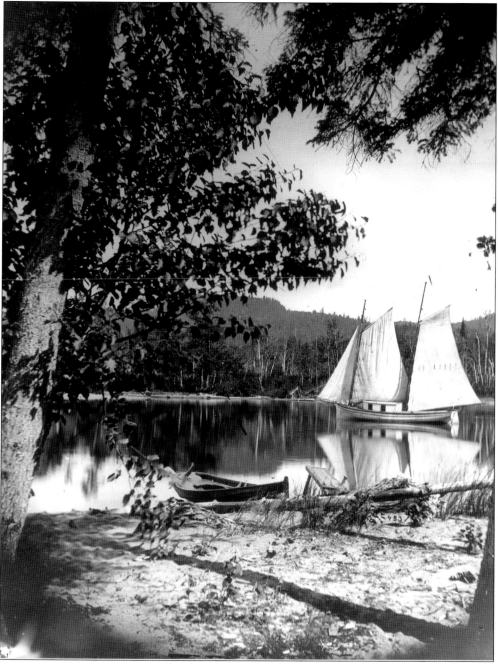

A SAILBOAT AT AN UNKNOWN UPPER PENINSULA LOCATION. (From the Collection of Jack Deo.)

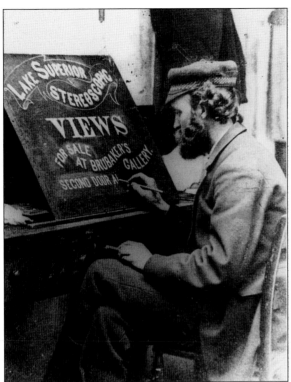

PHOTOGRAPHER B.F. CHILDS, PAINTING A SIGN FOR HIS STORE IN THE 1870s. Many of the historically valuable 19th-century photos of Lake Superior originate from him. (From the Collection of Jack Deo.)

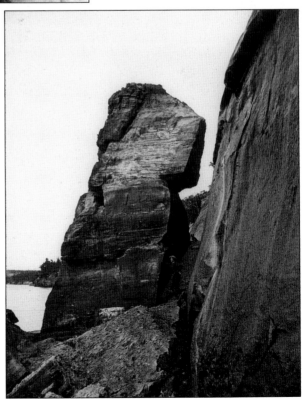

A MAN AT THE PICTURED ROCKS. (From the Collection of Jack Deo.)

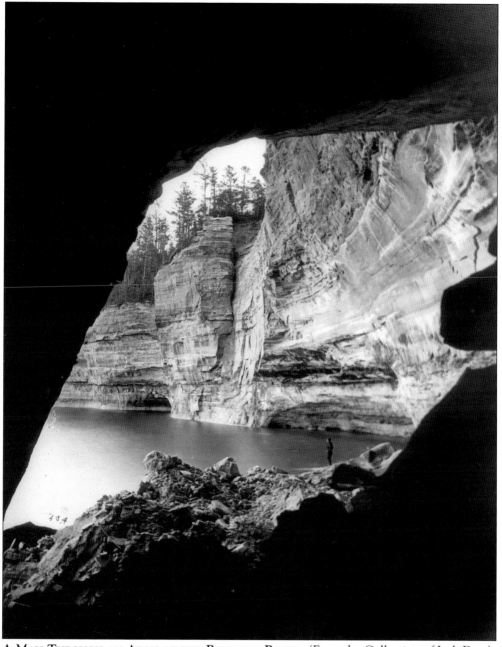

A MAN THROUGH AN ARCH AT THE PICTURED ROCKS. (From the Collection of Jack Deo.)

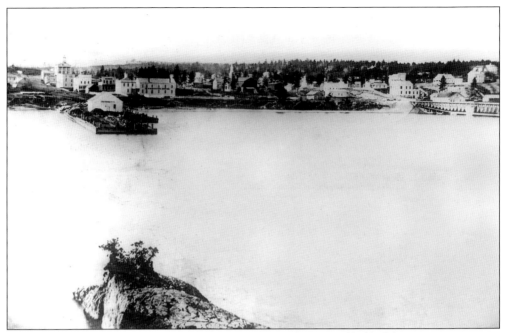

MARQUETTE FROM THE SHORELINE IN THE 1860S. In the second half of the 1800s, Marquette was emerging as the "queen city" of the Upper Peninsula, surrounded by what many travelers considered a wilderness. One New York correspondent wrote of Marquette that it is "the highest civilization in strange juxtaposition with the fiercest wilderness." (From the Collection of Jack Deo.)

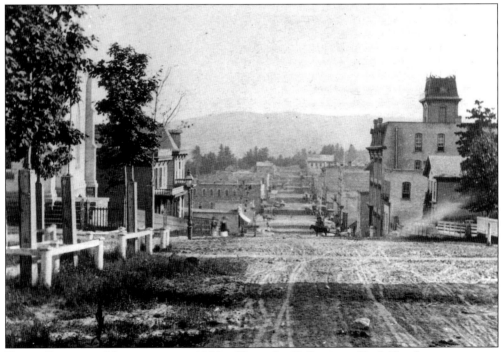

FRONT STREET OF MARQUETTE, C. 1860S. (From the Collection of Jack Deo.)

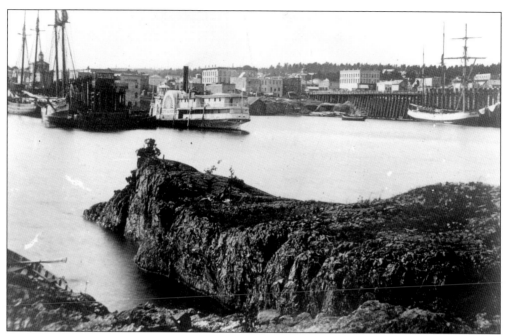

MARQUETTE IN THE 1870S. A propeller rests in the harbor and a schooner awaits a load of iron ore. (From the Collection of Jack Deo.)

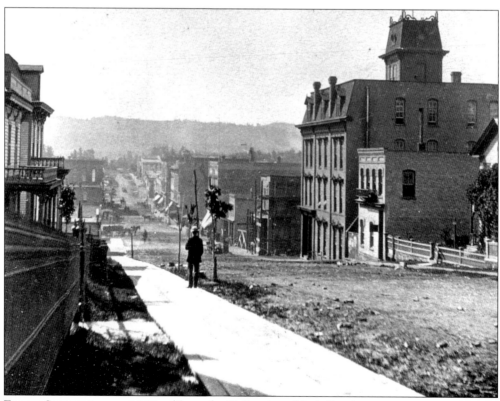

FRONT STREET IN THE 1870S. (From the Collection of Jack Deo.)

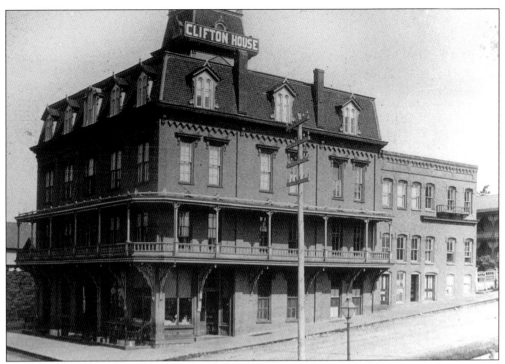

THE CLIFTON HOUSE. The Clifton House in Marquette competed with rival hotels for patronage as well as competing for the hotel that could serve the best whitefish. (From the Collection of Jack Deo)

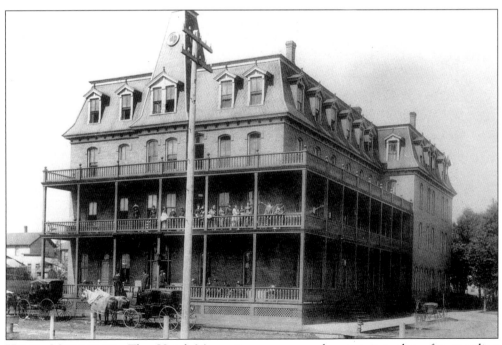

HOTEL MARQUETTE. The Hotel Marquette was a popular stopping place for traveling businessmen. (From the Collection of Jack Deo)

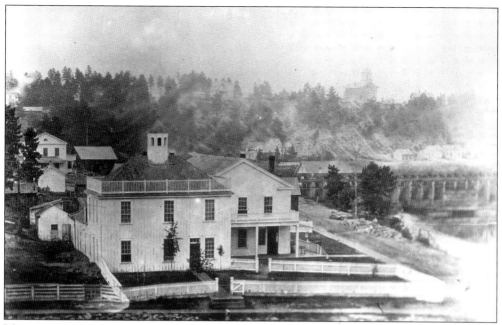

MARQUETTE, C. 1865. (From the Collection of Jack Deo.)

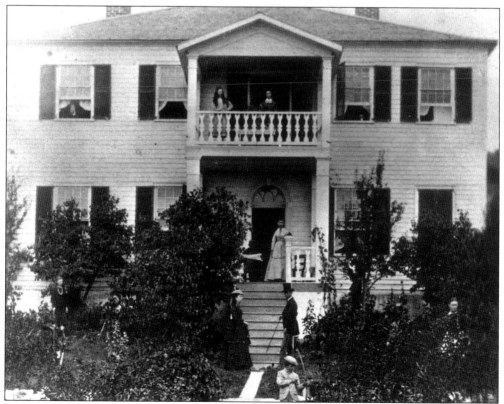

TODD HOUSE, MACKINAC ISLAND. The boy in the forefront tests his new bow. (From the Collection of Jack Deo.)

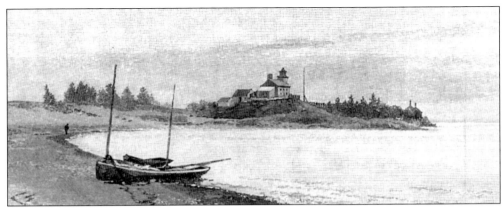

Sketch of the Lighthouse at Marquette. The first lighthouse was built in 1853, but was totally reconstructed in 1866. (From *Harper's Magazine*, December 1891–May 1892.)

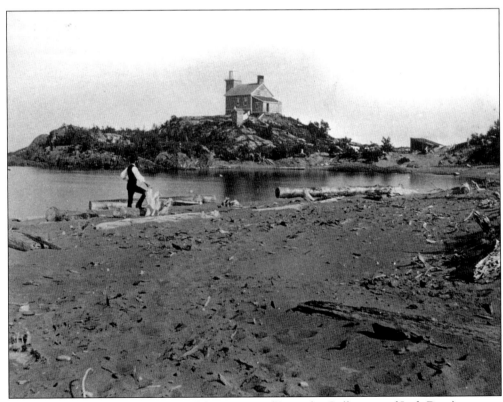

A Photo of the Lighthouse at Marquette. (From the Collection of Jack Deo.)

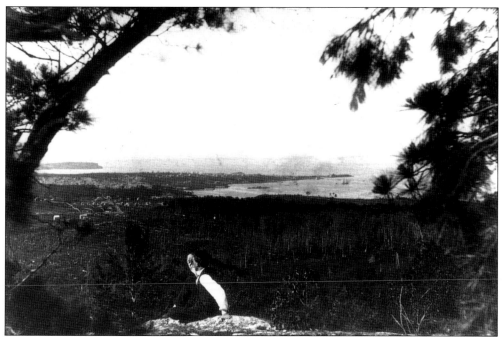

A Man Atop Mount Marquette in the 1870s. (From the Collection of Jack Deo.)

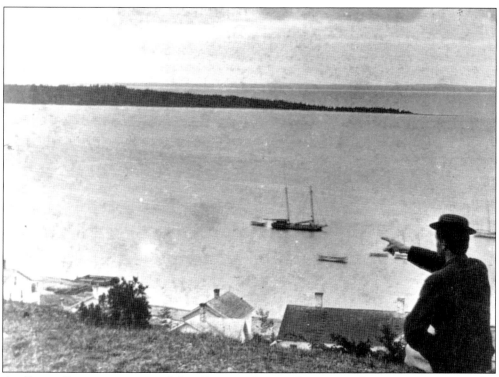

An Early Photograph of a Man Sitting Atop a Bluff on Mackinac Island. In this c. 1860 photograph, it is probable he is scanning the horizon looking for incoming ships, and finally noticed one. (From the Collection of Jack Deo.)

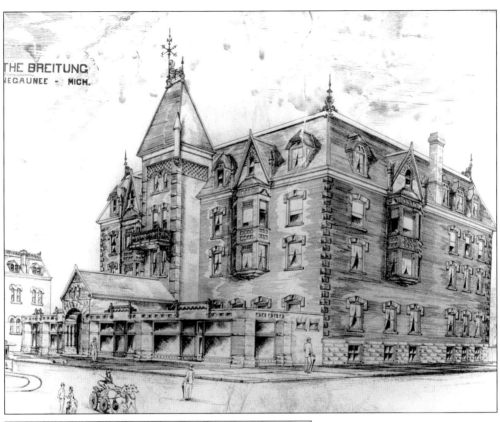

THE BREITUNG HOTEL.
Located in Negaunee, it was
built in part to accommodate
miners and overseers of mining
activities. It was named for
Edward Breitung, who served
as mayor of Negaunee, and a
member of the State and U.S.
Legislature. The hotel later
burned while being renovated.
(From the Collection of
Jack Deo.)

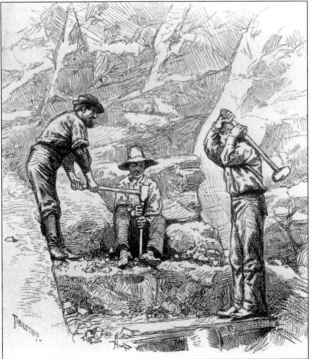

MINERS DRIVING A HOLE. This
sketch appeared in *Harper's
Magazine* in the 1880s. (From
Harper's Magazine, December
1881–May 1882.)

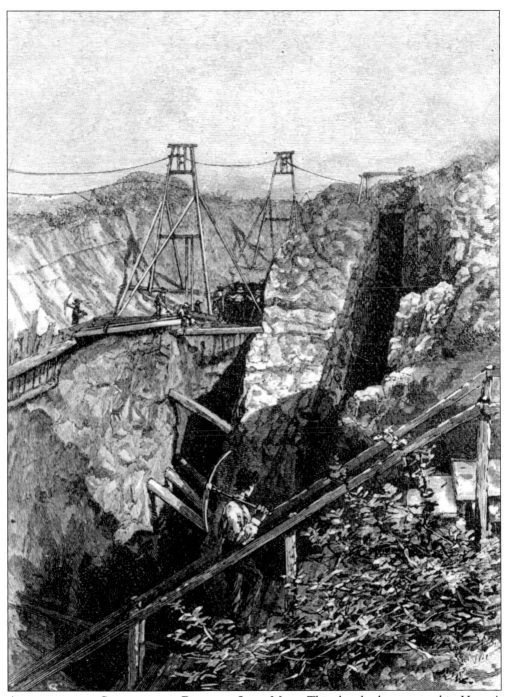

ASCENDING THE SLOPE AT THE REPUBLIC IRON MINE. This sketch also appeared in *Harper's Magazine* in the 1880s in an article on the Upper Peninsula. (From *Harper's Magazine*, December 1881–May 1882.)

STEAMBOAT LINE — 1874.

L'Anse, Houghton & Hancock

TRANSIT COMPANY.

DAILY LINE TO AND FROM L'ANSE,

Passing through Portage Lake and Keweenaw Bay.

THE SPLENDID SIDE-WHEEL STEAMER
"IVANHOE," Capt. McCullough,

Will leave **Hancock** and **Houghton** every morning, connecting with the afternoon train at L'Anse for Marquette, and all points East.

RETURNING, leave **L'Anse** in the afternoon, giving from two to three hours at L'Anse each way — forming a most delightful Excursion.

ADVERTISEMENT FOR THE L'ANSE, HOUGHTON, AND HANCOCK TRANSIT COMPANY FROM A GUIDEBOOK TO LAKE SUPERIOR IN 1874. (From *Sailing On the Great Lakes and Rivers of America*, by J. Disturnell, 1874.)

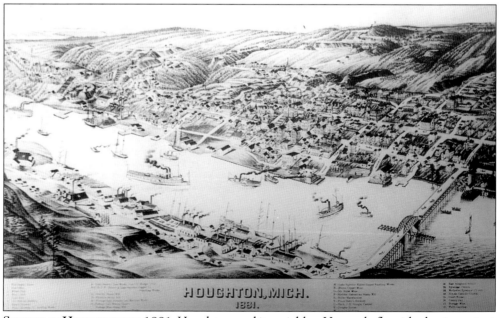

SKETCH OF HOUGHTON IN 1881. Houghton, and its neighbor Hancock, flourished as important mining hubs in the second half of the 1800s. (From the Collection of Jack Deo.)

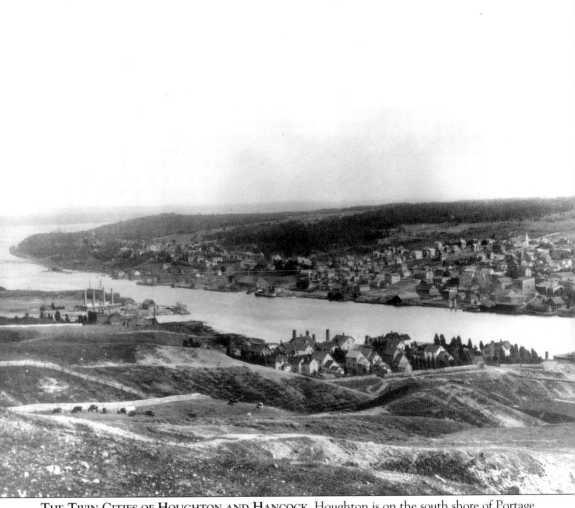

THE TWIN CITIES OF HOUGHTON AND HANCOCK. Houghton is on the south shore of Portage Lake and Hancock is to the north. Portage Lake, which nearly cuts all the way across the Keweenaw Peninsula, was a valuable transportation route for travelers wishing to reach the western areas of Lake Superior such as Ontonagon, since they could portage a couple of miles instead of sailing around the Keweenaw Peninsula. There were ongoing efforts in the second half of the 1800s to dig and improve ditches across the small strip of land that connects the Keweenaw Peninsula with the rest of the Upper Peninsula. (From the Collection of Jack Deo.)

FORT WILKINS, COPPER HARBOR. Fort Wilkins was originally created to ensure protection for inhabitants near Copper Harbor during the mining boom of the 1840s. Later, however, the fort took on a new role according to an 1856 guidebook to Lake Superior. It claimed the fort was "converted into a hotel and water-cure establishment for the accommodation for visitors." (From the Collection of the Michigan Historical Museum/Fort Wilkins Complex.)

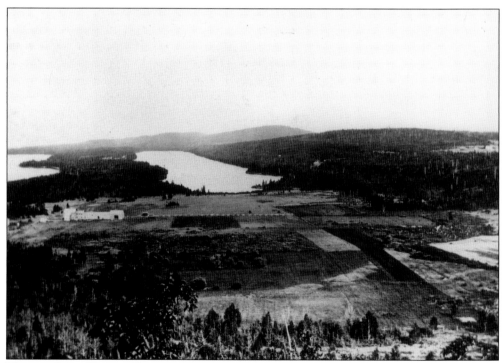

VIEW OF LAKE FANNY HOE NEAR COPPER HARBOR. This beautiful lake was hailed by many travelers for its "health giving properties." (From the Collection of the Michigan Historical Museum/Fort Wilkins Complex.)

A Schooner at Escanaba Awaiting a Load of Iron Ore. One guidebook from the Lake Superior region claimed that in Escanaba "the naturalist finds the curious in nature, while the practical can investigate the mines of iron." (From the Collection of Jack Deo.)

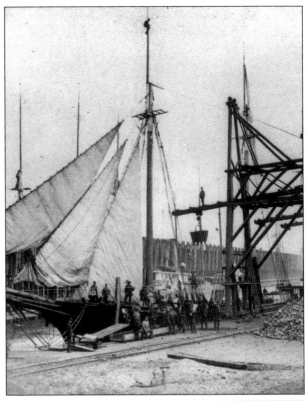

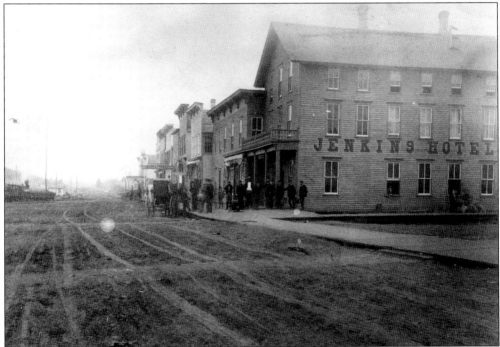

The Jenkins House on Stephenson Avenue in Iron Mountain in the 1880s. (From the Collection of Jack Deo.)

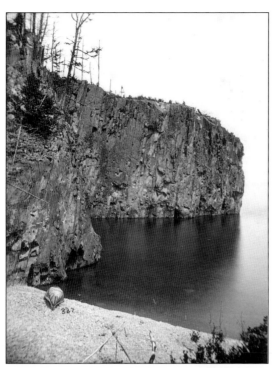

AN OVERTURNED CANOE ON THE NORTH SHORE OF LAKE SUPERIOR. (From the Collection of Jack Deo.)

A BEACHED MACKINAW BOAT ON THE SHORE OF MIDDLE ISLAND POINT IN THE 1870S. (From the Collection of Jack Deo.)

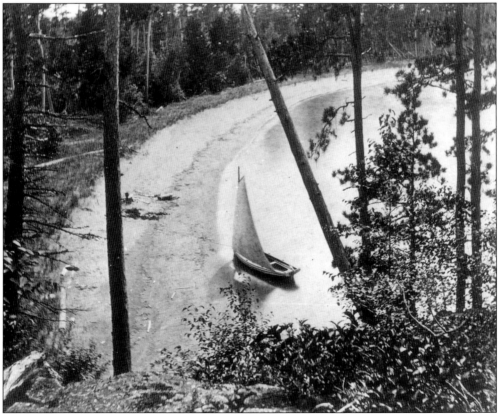

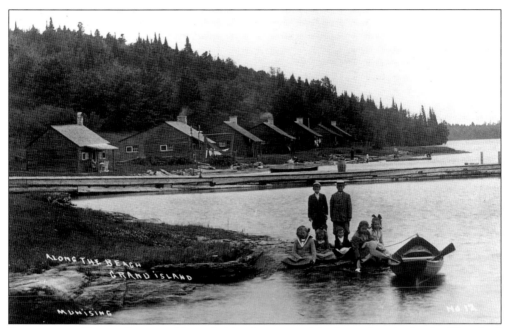

SCENE FROM GRAND ISLAND. Most of this picturesque island was bought by the Cleveland Cliffs Company by the 1900s. (From the Collection of Jack Deo.)

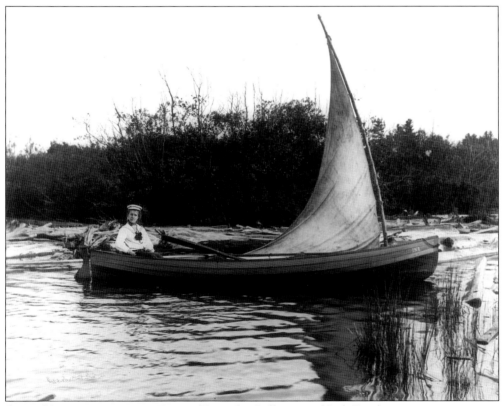

CLOSE UP OF A MACKINAW BOAT. (From the Collection of Jack Deo.)

GRAND PLEASURE EXCURSION
FROM NEW YORK TO LAKE SUPERIOR & ST. PAUL,
via NIAGARA FALLS.

STOPPING PLACES.		MILES.
NEW YORK to ALBANY, *(Railroad or Steamer,)*		**145**
ALBANY TO ROCHESTER, *(Railroad,)*..........229—		**374**
ROCHESTER TO BUFFALO................... 69—		**443**
BUFFALO TO CLEVELAND, *via Lake Shore Route* 183—		**626**
ROCHESTER TO NIAGARA FALLS, *(Susp'n Bridge,)* 75—		**448**
SUSPENSION BRIDGE TO HAMILTON, Canada..... 43—		**491**
HAMILTON TO DETROIT, Mich.................187—		**678**
DETROIT TO CHICAGO, *via Mich. Central R. R.*..284—		**962**

TABLE ROCK.

Detroit to Port Huron, *(Steamboat Route,)*.............. 73—		**751**
PORT HURON TO DE TOUR, *(Lake Huron,)*........................225—		**976**
DE TOUR, (Mouth St. Mary's River,) to SAUT STE. MARIE............ 50—		**1,026**
SAUT STE. MARIE TO MARQUETTE, *(Lake Superior,)*.................170—		**1,196**
MARQUETTE TO PORTAGE ENTRY........ 75—		**1,271**
PORTAGE ENTRY TO COPPER HARBOR........................... 63—		**1,334**
COPPER HARBOR TO ONTONAGON............................. 92—		**1,426**
ONTONAGON TO BAYFIELD, Wis................................. 88—		**1,514**
BAYFIELD TO DULUTH.. 88—		**1,602**
DULUTH TO ST. PAUL, Minn., *(L. S. & Miss. R. R.)*...154—		**1,756**
ST. PAUL TO CHICAGO, *(Direct Railroad Route,)*.................. —		**410**
CHICAGO TO NEW YORK, *via Detroit*..........................962—		**1,404**

☞ THIS RAILROAD and STEAMBOAT ROUTE from the **City of New York** to **St. Paul**, Minn., via Niagara Falls, Lakes Huron and Superior,—passing the Island of Mackinac, the Saut Ste. Marie, and the Pictured Rocks,—a total Distance of 1,756 Miles, affords the invalid, and seeker of pleasure, during the Summer months, one of most healthy, interesting, and **Grand Excursions** on the Continent of America.

67

1870S EXCURSIONS. This is an advertisement for a "grand pleasure excursion" from a guidebook to Lake Superior in the 1870s. (From *Sailing On the Great Lakes and Rivers of America*, by J. Disturnell, 1874.)

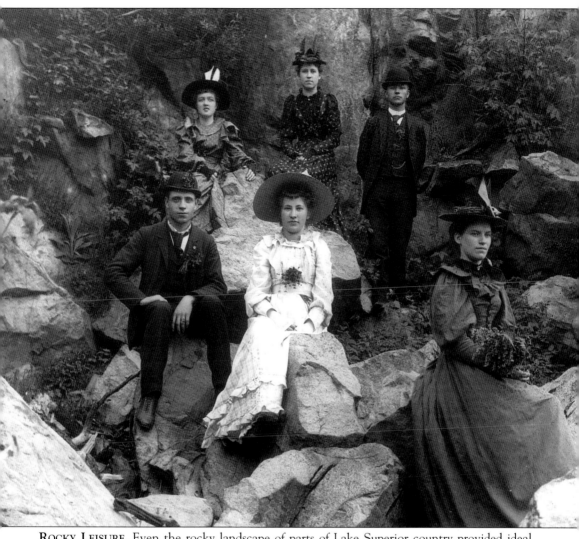

ROCKY LEISURE. Even the rocky landscape of parts of Lake Superior country provided ideal spots for leisure. (From the Collection of Jack Deo.)

ADVERTISEMENT FROM A GUIDEBOOK TO LAKE SUPERIOR IN 1874. This advertisement makes an appeal to travelers in search of "health and pleasure." Many travelers and guidebooks vaguely spoke of the "health giving properties" of the Lake Superior region. (From *Sailing On the Great Lakes and Rivers of America*, by J. Disturnell, 1874.)

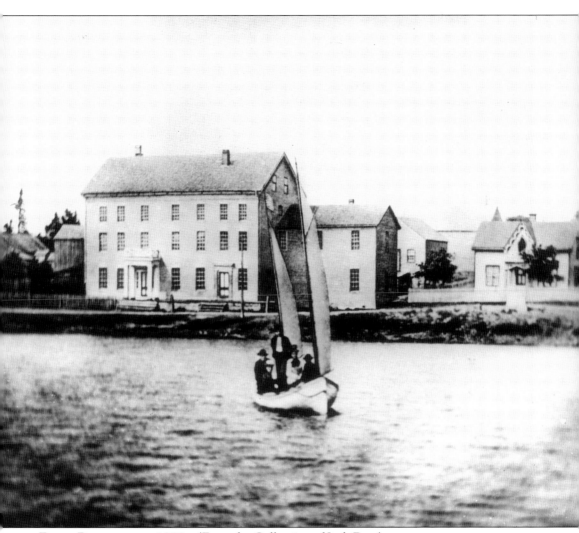

EAGLE RIVER IN THE 1880s. (From the Collection of Jack Deo.)

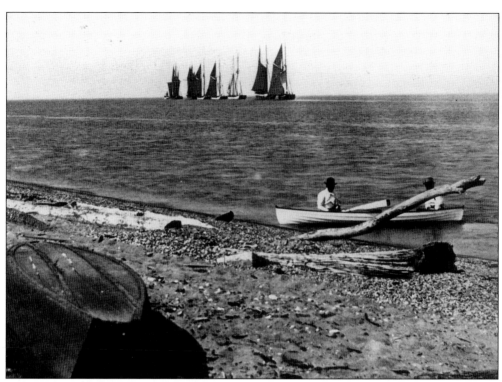

A Cluster of Schooners in the 1860s. (From the Collection of Jack Deo.)

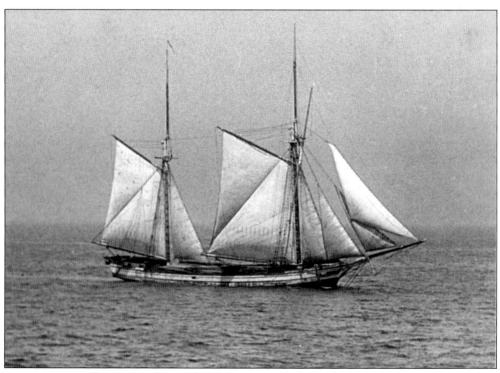

Close Up of a Schooner. (From the Collection of Jack Deo.)

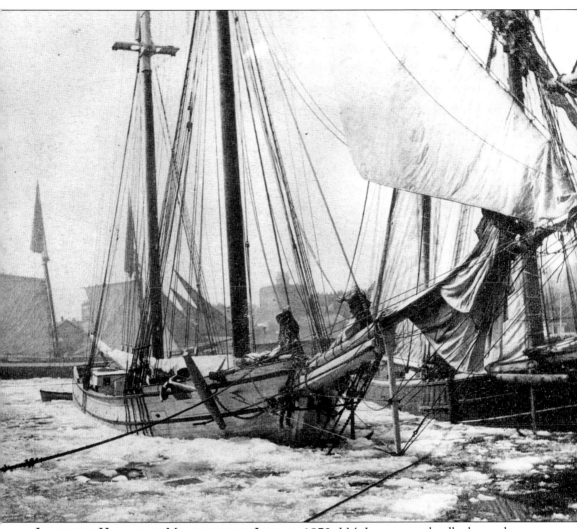

ICE IN THE HARBOR OF MARQUETTE IN JUNE OF 1873. J.M. Longyear, a landlooker and one of the pioneers of the Huron Mountain Club, arrived in Marquette for the first time that year on a steamer, which he had to slowly maneuver through the dangerous floating ice. (From the Collection of Jack Deo.)

MARQUETTE IN THE 1870S. (From the Collection of Jack Deo.)

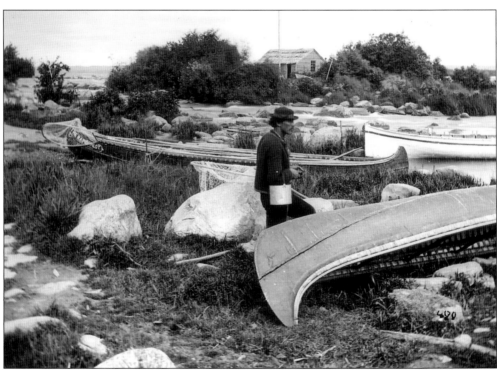

A NATIVE-AMERICAN RAPIDS PILOT AND HIS CANOE AT SAULT STE. MARIE AROUND 1870. (From the Collection of Jack Deo.)

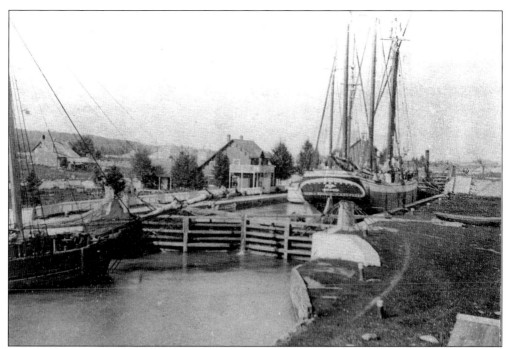

ENTRANCE TO THE LOCK AT SAULT STE. MARIE IN THE 1870S. A new lock was completed and the canal deepened in the 1870s to accommodate the increasing Lake Superior traffic. (From the Collection of Jack Deo.)

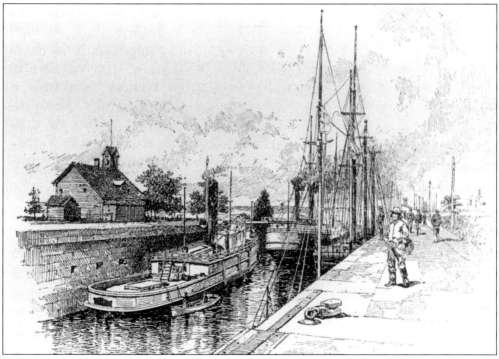

THE LOCK AT SAULT STE. MARIE. (From *Harper's Magazine*, December 1891–May 1892.)

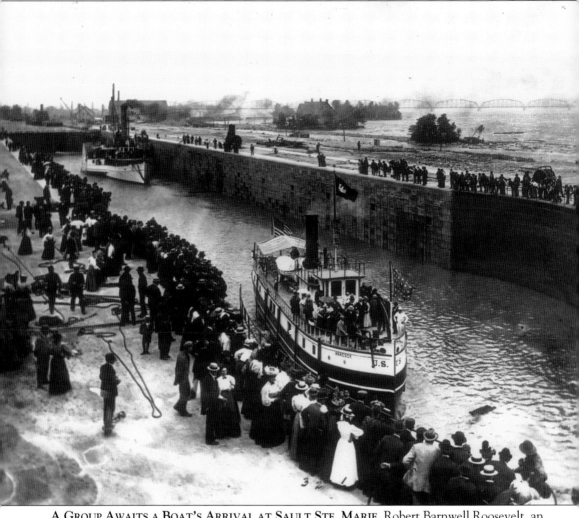

A GROUP AWAITS A BOAT'S ARRIVAL AT SAULT STE. MARIE. Robert Barnwell Roosevelt, an avid angler and uncle of Theodore Roosevelt, wrote of his arrival to Sault Ste. Marie in 1865: "She (the steamer) whistled merrily to announce to the inhabitants that once more she was to bless their sight, and tried to get a little extra steam for a final burst. The travelers crowded her docks, the natives collected along the shore, the former waved their handkerchiefs, the latter, probably having no handkerchiefs, swung their hats, and amid all this excitement, we came merrily up to the dock." (From the Collection of Jack Deo.)

Four

RAILROADS
AND SPORTING
1870s–1900

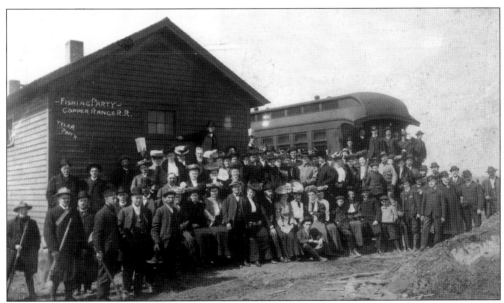

A LARGE FISHING PARTY ASSEMBLES FOR A PHOTOGRAPH ALONG THE COPPER RANGE IN THE 1890S. When the railroads began connecting to Upper Peninsula towns from more urban areas, there were new opportunities for sportsmen and sportswomen, since they could take advantage of the vast hunting and fishing grounds in the inland Upper Peninsula. Travel was no longer confined to water transportation associated with Lake Superior, and the time it took for people wishing to experience the outdoors of the Upper Peninsula from places like Chicago, Detroit, and Milwaukee was dramatically decreasing. (From the Collection of Jack Deo.)

RAILROAD AND STEAMBOAT ROUTE,

FROM CHICAGO TO GREEN BAY AND MARQUETTE, LAKE SUPERIOR.

Chicago and North-Western Railroad.

MILES.	STATIONS.		MILES.
242	**CHICAGO**		0
230	Canfield		12
225	Des Plaines	5	17
220	Dunton	5	22
216	Palatine	4	26
210	Barrington	6	32
199	Crystal Lake	11	43
196	Ridgefield	3	46
191	Woodstock	5	51
179	Harvard Junction	12	63
177	Lawrence	2	65
164	Clinton Junction	13	78
160	Shopiere	4	82
151	**Janesville**	9	91
143	Milton Junction	8	99
131	Fort Atkinson	12	111
125	Jefferson	6	117
120	Johnson's Creek	5	122
112	Watertown	8	130
97	Juneau	15	145
94	Minn. Junction*	3	148
90	Burnett	4	152

MILES.	STATIONS.		MILES.
82	Chester	8	160
74	Oakfield	8	168
65	**Fond du Lac**	9	177
49	Oshkosh	6	193
35	Neenah	14	207
29	Appleton	6	213
24	Little Chute	5	218
21	Kaukauna	3	221
16	Wrightstown	5	226
6	De Pere	10	236
0	Fort Howard	6	242
	Green Bay		0
189	**GREEN BAY,**		242
161	Oconto	28	270
140	Marinette	21	291
138	Menomonee	2	293
74	**Escanaba**	64	357
	Peninsula Division.		
61	Day's River	13	370
54	Centerville	17	387
12	Negaunee	32	419
	Marquette, Houghton & Ontonagon R.R.		
0	**MARQUETTE**	12	431

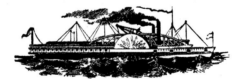

Steamers run daily from MARQUETTE to the Saut Ste. Marie on the East, 170 miles; and to Houghton, Ontonagon, Bayfield, and Duluth on the West; a total distance of 400 miles,—passing around Keweenaw Point. This distance can be shortened about 100 miles by passing the Portage and Lake Superior Ship Canal.

ADVERTISEMENT FOR RAILROAD AND STEAMBOAT ROUTES. After the railroad and steamer lines were established, travel became much more structured and punctual. (From *Sailing On the Great Lakes and Rivers of America*, by J. Disturnell, 1874.)

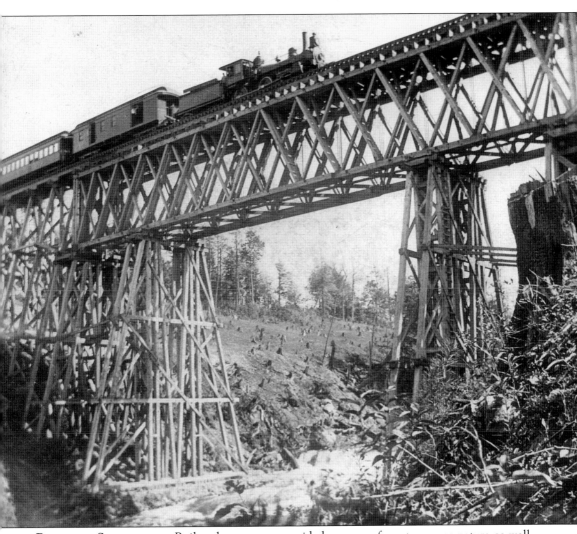

RAILROAD STRUCTURES. Railroad structures provided a sense of mastery over nature as well as excellent scenery for travelers. One guidebook wrote of the bridge over Ontonagon Falls, claiming: "the train leaps, from not at all extraordinary surroundings, out upon a bridge nearly 100-feet above the beautiful stream and seems as poised as a swallow in mid-air." (From the Collection of Jack Deo.)

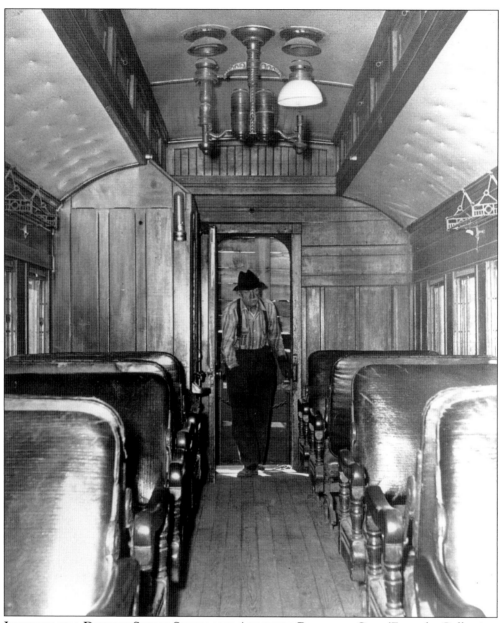

INTERIOR OF A DULUTH SOUTH SHORE AND ATLANTIC RAILROAD CAR. (From the Collection of Jack Deo.)

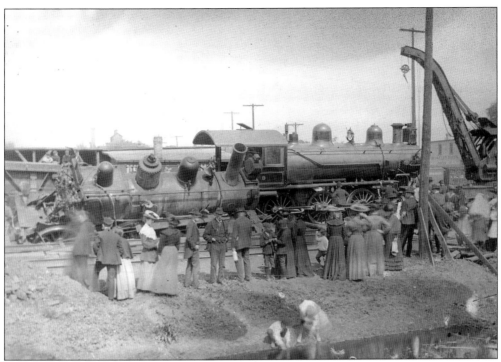

WATCHING A DERAILMENT ON THE COPPER RANGE. Children play in a pond as visitors watch a train derailment on the Copper Range near the turn of the century. (From the Collection of Jack Deo.)

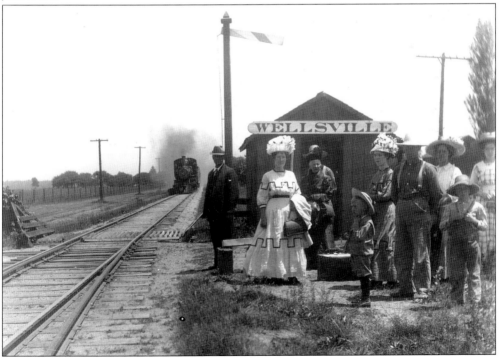

PASSENGERS AWAIT AN INCOMING TRAIN. (From the Collection of Jack Deo.)

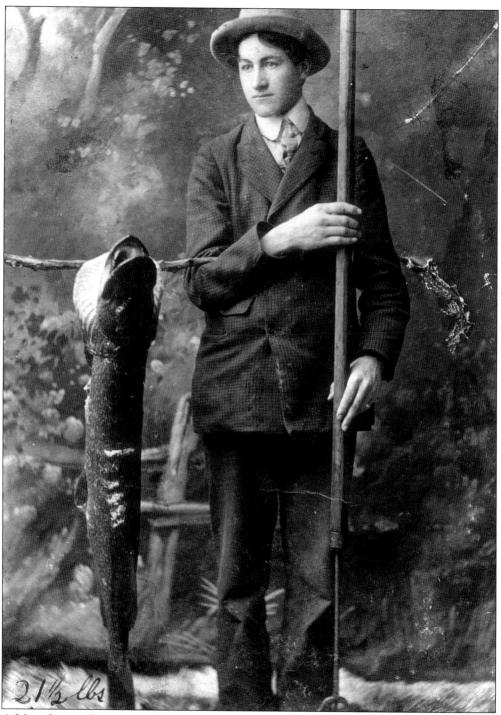

2 1/2 lbs

A Man Shows Off a 21 1/2-Pound Muskellunge. (From the Collection of Jack Deo.)

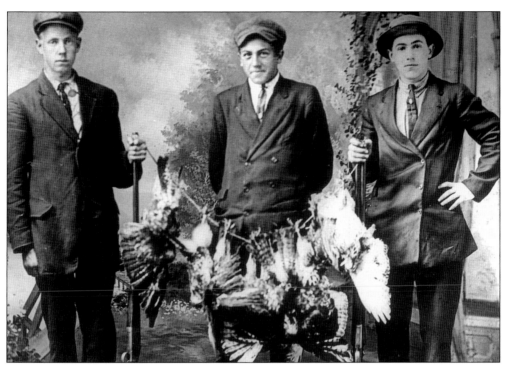

HUNTERS SHOW OFF THEIR FOWL. (From the Collection of Jack Deo.)

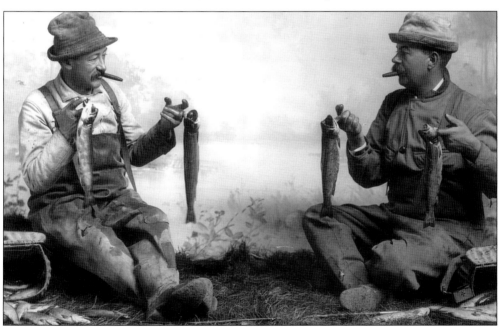

ANGLERS SMOKE A CIGAR AFTER A GOOD DAY OF TROUT FISHING. Trout fishing on inland streams grew with the development of the railroads. In the late 1870s, a group of prominent lawyers from Chicago took advantage of the Chicago and North-Western Railway to fish the streams of the western Upper Peninsula and northern Wisconsin. They subsequently wrote of their journey in an 1880 publication titled *Trouting on the Brule River*. (From the Collection of Jack Deo.)

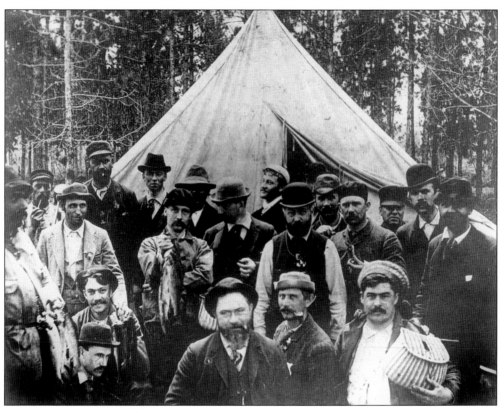

SCENE FROM A FISHING TRIP IN 1892. (From the Collection of Jack Deo.)

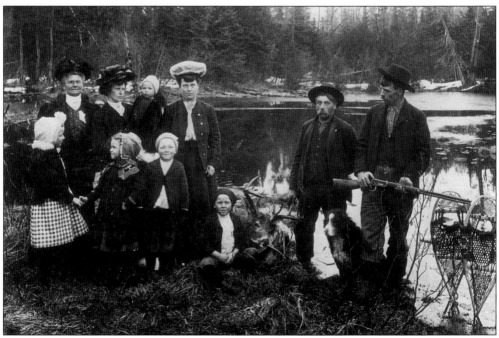

A SUCCESSFUL DEER HUNT. (From the Collection of Jack Deo.)

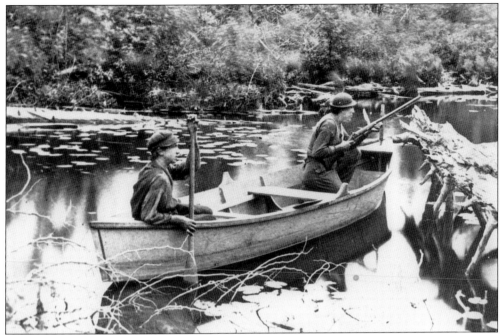

HUNTING FROM A BOAT. (From the Collection of Jack Deo.)

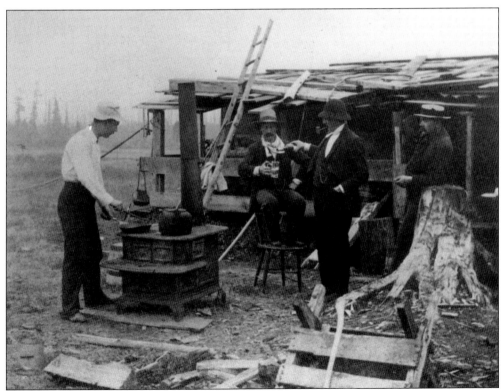

HUNTING CAMPS. Some hunting camps were better equipped than others. This camp is lavishly equipped with a wood-burning stove. (From the Collection of Jack Deo.)

MARQUETTE ADVERTISEMENTS, C. 1870S. This is a page of advertisements for the Marquette area from a guidebook to Lake Superior in the 1870s. (From *Sailing On the Great Lakes and Rivers of America*, by J. Disturnell, 1874.)

SPECKED TROUT DRESSED UP FOR THE CAMERA. Fishing in inland streams for trout became much more popular after the railroad connections to the Upper Peninsula. Photographed by B.F. Childs. (From the Collection of Jack Deo.)

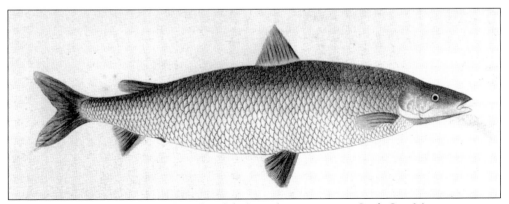

A SKETCH OF A WHITEFISH. The whitefish from the waters near Sault Ste. Marie were quite celebrated in the 1800s. The English traveler Anna Jameson claimed to "have eaten them fresh out of the river 4 times a day." She added "I have never tasted anything of the fish kind half so exquisite." (From *Sketches of a Tour to the Lakes,* by Thomas L. Mckenney, 1827.)

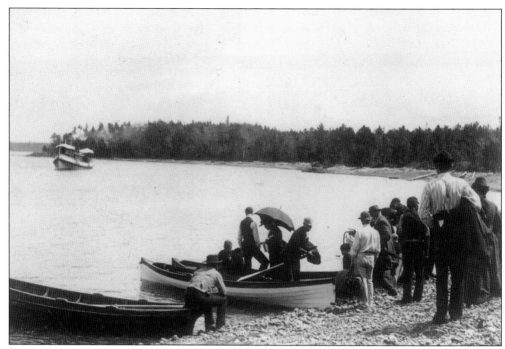

PLEASURE TRAVELERS READY TO EMBARK NEAR COPPER HARBOR IN THE 1890S. (From the Collection of the State Archives of Michigan.)

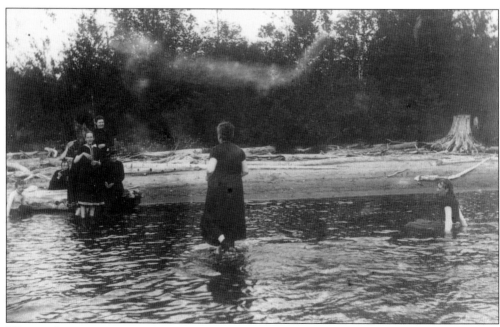

WOMEN SWIMMING IN THE FRIGID WATERS OF LAKE SUPERIOR NEAR COPPER HARBOR. One guidebook to Lake Superior near the turn of the century somewhat humorously noted "bathing is a favorite pastime, especially on the inland lakes. In some places suits can be rented, but generally it will be more satisfactory for those who intend to bathe to be provided with their own." (From the Collection of the State Archives of Michigan.)

A Group of Boaters Pose for the Camera. (From the Collection of the Marquette Historical Society.)

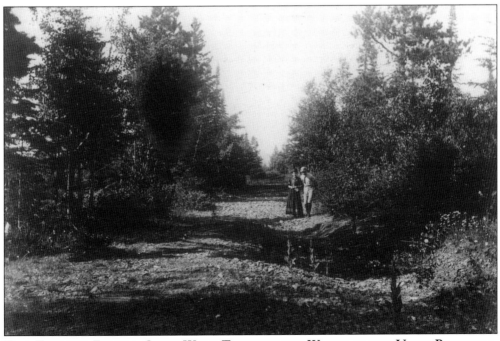

Two Tourists Enjoy a Quiet Walk Through the Woods of the Upper Peninsula. One guidebook from the late 1800s claimed no tourist could do justice to their trip to the Upper Peninsula, "without at least a taste of life in the woods and near nature's heart." (From the Collection of the State Archives of Michigan.)

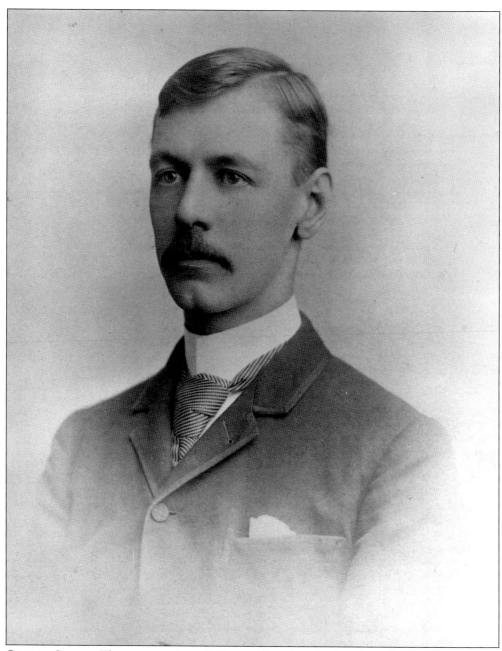

GEORGE SHIRAS. Three generations of George Shiras' made the Upper Peninsula a seasonal home, starting in the late 1850s. George Shiras III, the pioneer of flash bulb photography, recognized the recreational possibilities of the Upper Peninsula, as he once indicated "The Upper Peninsula, with little prospect of any development of agriculture or manufacturing, seems destined to a long future as a recreational wilderness area." (From the Collection of Jack Deo.)

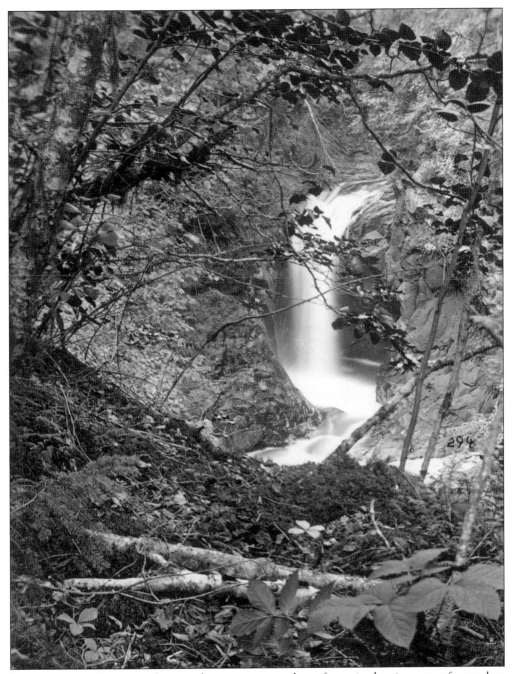

EXHILARATING FREEDOM. Spectacular scenery was a large factor in drawing many from urban areas to more remote locations like the Upper Peninsula. One fisherman and lawyer from Chicago remarked in 1880 on a visit to the Upper Peninsula, that: "the restraints and stress of civilization and the city, for the time, are exchanged for the exhilarating freedom and simplicity of nature." (From the Collection of Jack Deo.)

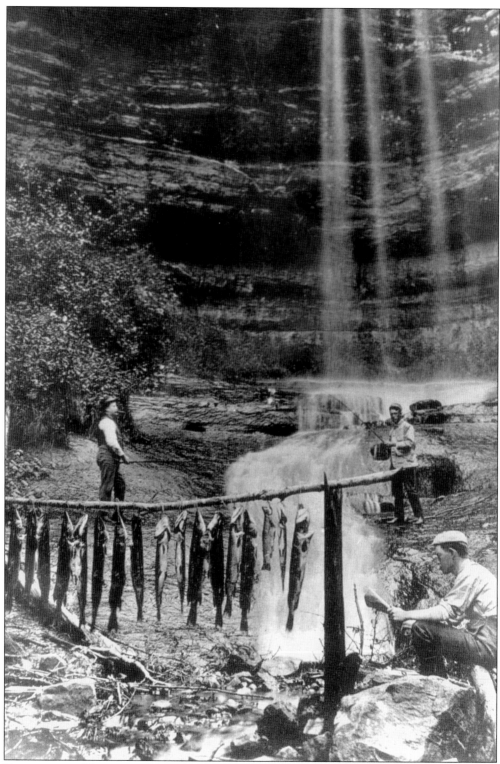

Fishing near Munising Falls. (From the Collection of Jack Deo.)

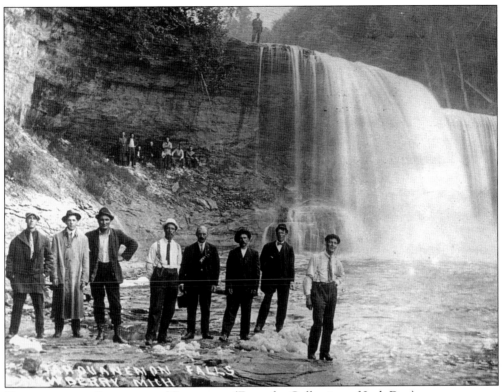

TAHQUAMENON FALLS, NEAR NEWBERRY. (From the Collection of Jack Deo)

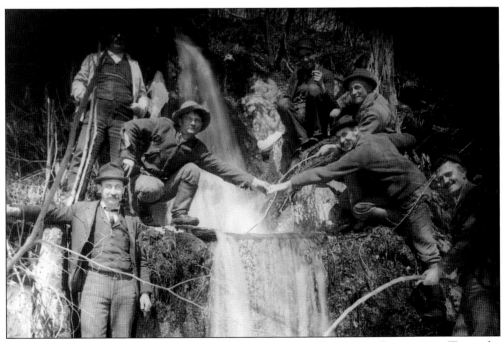

A GROUP HAS SOME FUN FOR THE CAMERA AT AN UNKNOWN LOCATION. (From the Collection of Jack Deo.)

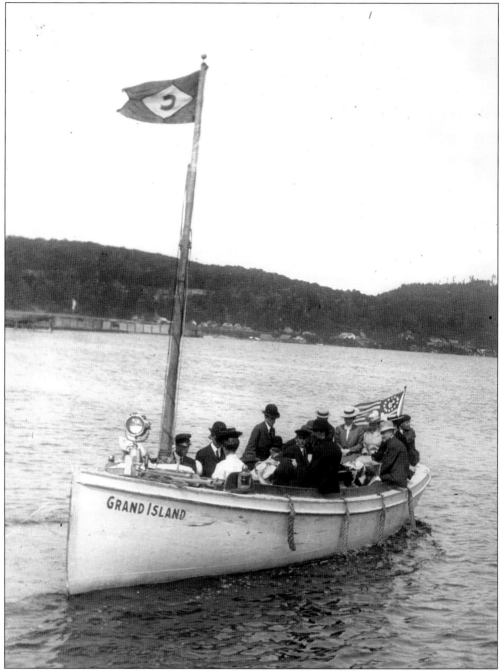

A GRAND ISLAND PLEASURE CRUISE. The "C" on the flag probably stands for Cleveland Cliffs, as the company bought much of the island by the 1900s. (From the Collection of Jack Deo.)

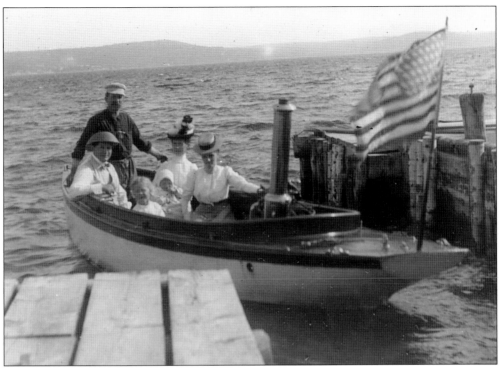

A Motorized Boat Sets Sail. Eventually, motorized boat travel conveniently replaced the toil of traveling by the wind. (From the Collection of Jack Deo.)

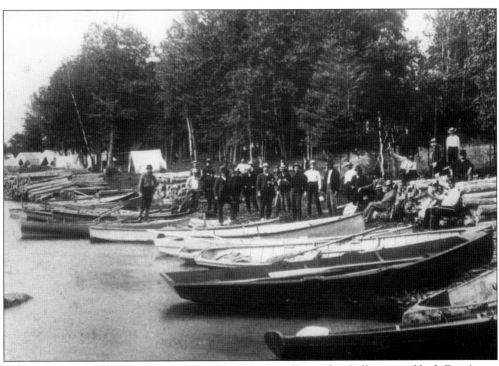

A Large Fishing Party Gets Ready to Embark. (From the Collection of Jack Deo.)

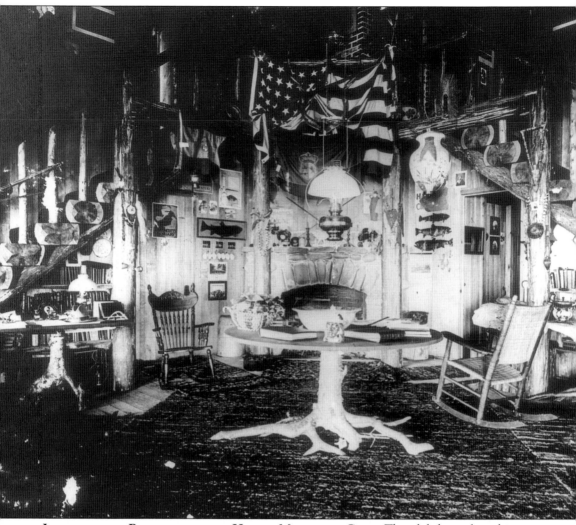

INTERIOR OF A BUILDING AT THE HURON MOUNTAIN CLUB. The club has a long history, as it was originally organized in 1889 as "The Huron Mountain Shooting and Fishing Club." The club was pioneered by Horatio Seymour and J. M. Longyear, and attracted members from Marquette, Chicago, and Detroit. The club is still in operation today. (From the Collection of Jack Deo.)

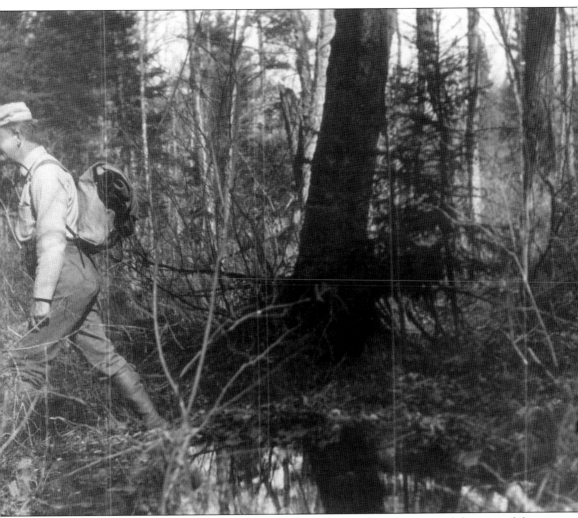

CYRUS MCCORMICK. Cyrus McCormick strolls along the Bentley Trail around the turn of the century. McCormick's father achieved fame by inventing the reaper, which made significant changes in the structure of American agriculture. The Chicagoan Cyrus McCormick loved the great outdoors that the Upper Peninsula had to offer. (From the Collection of Jack Deo.)

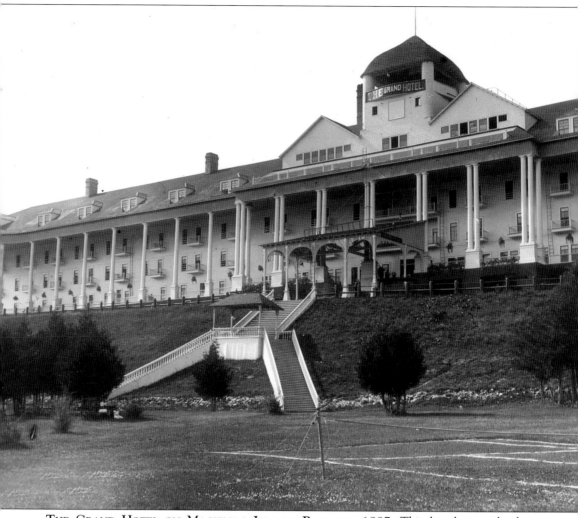

THE GRAND HOTEL ON MACKINAC ISLAND, BUILT IN 1887. This hotel gave the long established resort of Mackinac Island even more of a reputation for first class accommodations, on an island seemingly surrounded by a more rugged landscape. (From the Collection of Jack Deo.)

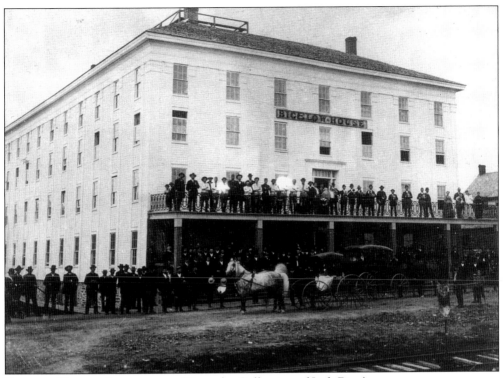

BIGELOW HOUSE, ONTONAGON. (From the Collection of Jack Deo.)

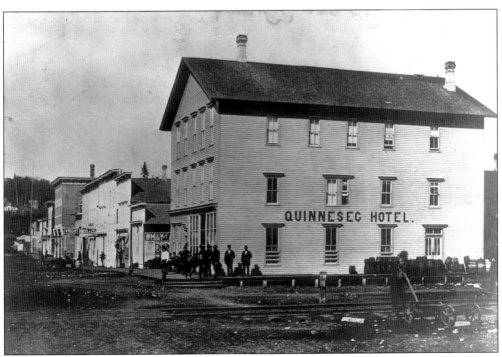

QUINNESEC HOTEL ALONG QUINNESEC AVENUE IN THE 1880S. (From the Collection of Jack Deo.)

NEGAUNEE IN THE 1880S. To many urban visitors, the mining town of Negaunee was a dramatic departure from their customary lifestyle. One traveler in the 1880s thought it was a "strange world of rock red with iron." (From the Collection of Jack Deo.)

IRON STREET IN NEGAUNEE. (From the Collection of Jack Deo.)

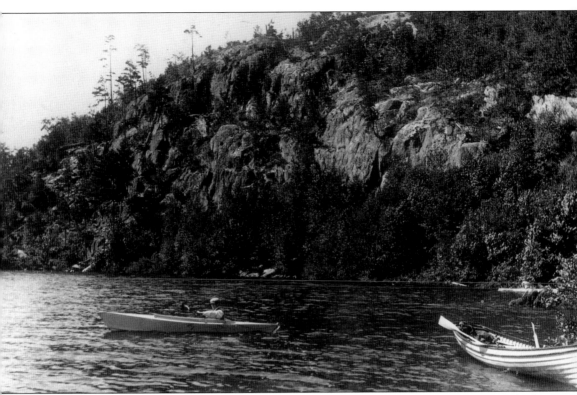

A Kayak on Teal Lake in Negaunee in the 1880s. This one-time camping ground of the Native Americans proved to have abundant recreational possibilities. One of the first camps in the region was built on the south shore of Teal Lake in the 1850s by James Reynolds of Ohio. Reynolds spent his summers there, while a local couple acted as winter supervisors. Unfortunately, the house burned in the early 1880s. (From the Collection of Jack Deo.)

ERIE RAILWAY.

This popular RAILWAY, extending from the City of New York, forms the most direct and speedy route through New Jersey and Southern New York to

ROCHESTER, BUFFALO, NIAGARA FALLS & DUNKIRK,

Connecting at these several points with Railroads running to

CANADA ON THE NORTH-WEST,

AND TO

OHIO, &c. ON THE SOUTH-WEST,

FORMING, IN CONNECTION WITH OTHER RAILROADS,

Through Lines of Travel

TO

DETROIT, CHICAGO, CLEVELAND, COLUMBUS, CINCINNATI, and ST. LOUIS.

For good management, low rates of fare, suitable equipment, regularity in the running of trains, and variety and richness of scenery, this Railway cannot be excelled.

Two of the finest **TRIPS** on this Continent, if not in the World, are those afforded by the Erie Railway: 1st. From New York to Niagara Falls, and thence via Lake Ontario and the River St. Lawrence to Montreal and Quebec.—2d. From New York to Buffalo or Cleveland, and thence via Lake Erie to Detroit, proceeding through the Upper Lakes to the Saut Ste. Marie, Marquette, Duluth, etc.

Other pleasure trips of almost equal interest are afforded by means of numerous connections with Railroads and Steamboat Lines running to Fashionable Resorts, both in the United States and Canada.

PRINCIPAL TICKET OFFICES.

241 Broadway, N. Y.; Depot, foot of Chambers St.; Depot, foot of Twenty-third St.

JOHN N. ABBOTT,

General Passenger Agent, New York.

PHILADELPHIA TICKET OFFICE, 732 Chestnut Street.

ERIE RAILWAY ADVERTISEMENT FROM 1874. The advertisement boasted that the railroad offered one of the finest trips on the continent, and was conveniently on its route from New York across the Upper Peninsula to Duluth. (From *Sailing On the Great Lakes and Rivers of America*, by J. Disturnell, 1874.)

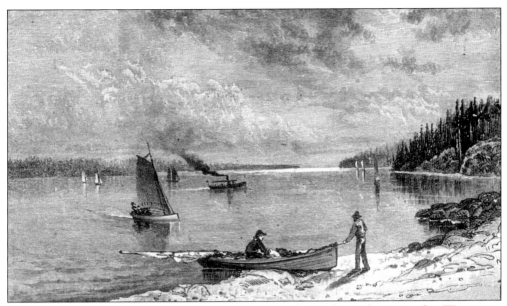

GOGEBIC LAKE. The popular 19th-century resort of Gogebic Lake, near the Wisconsin-Michigan border, was well connected by railroad routes. These connections brought a host of campers, anglers, and hunters from larger cities like Milwaukee and Chicago. (From *Forests, Streams, and Lakes of Northern Wisconsin and Michigan and Summer Homes*, 1884.)

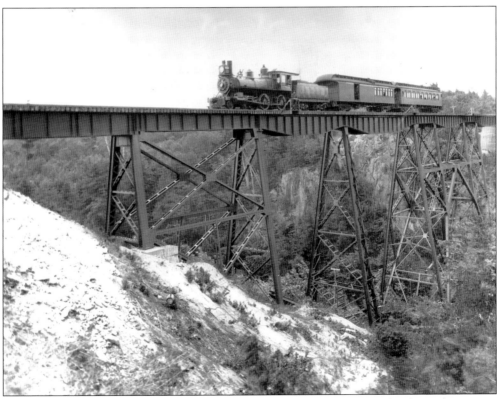

DEAD RIVER TRESTLE, ALONG THE L.S. AND I. (From the Collection of Jack Deo.)

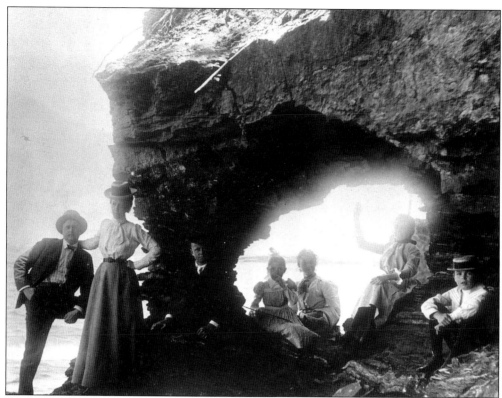

PICNICKERS AT PRESQUE ISLE, NEAR MARQUETTE. The area continues to this day to be a favorite picnic area. (From the Collection of Jack Deo.)

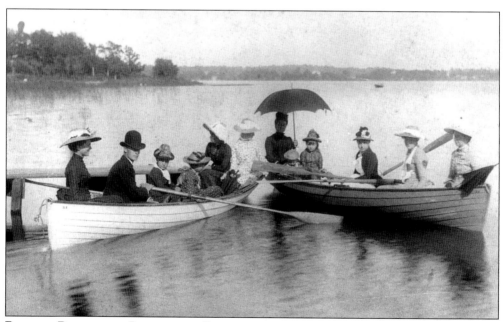

BOATERS POSE FOR AN INTERESTING PHOTOGRAPH AT AN UNKNOWN LOCATION. (From the Collection of Jack Deo.)

A Couple Takes a Leisurely Boat Ride. (From the Collection of the Marquette County Historical Society.)

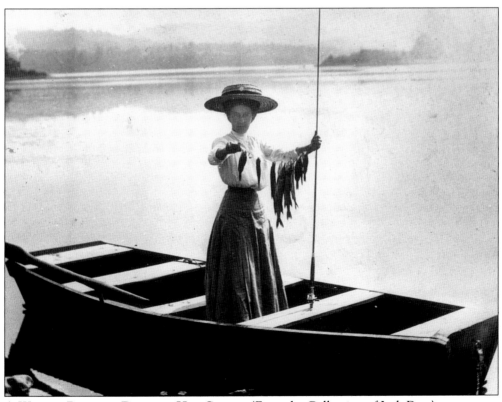

A Woman Proudly Displays Her Catch. (From the Collection of Jack Deo.)

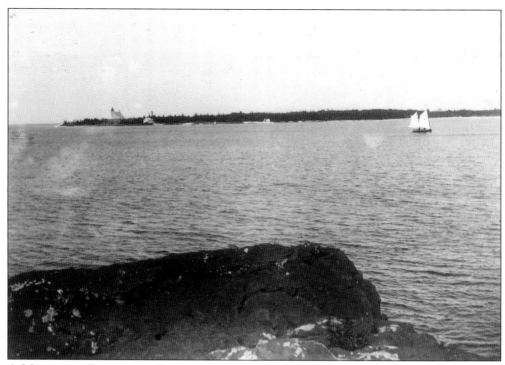

A MACKINAW BOAT NEAR COPPER HARBOR. (From the Collection of the State Archives of Michigan.)

A COUPLE FISH ON LAKE FANNY HOE IN THE 1890s. (From the Collection of the State Archives of Michigan.)

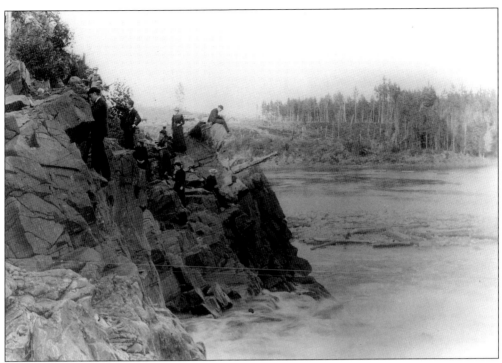

PICNICKERS NEAR MENOMINEE. (From the Collection of Jack Deo.)

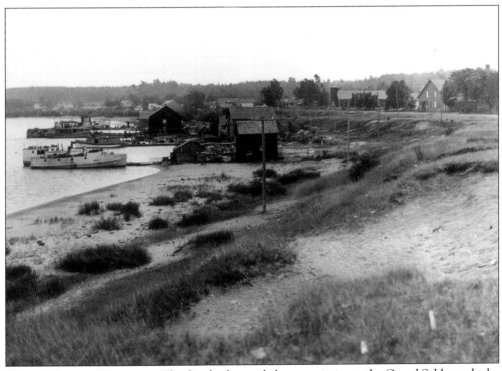

GRAND MARAIS, MICHIGAN. The fine harbor and close proximity to the Grand Sable made the area a frequent stopping place for travelers. (From the Collection of Jack Deo.)

NEW
Indian Curiosity Store.

The largest, best assorted and cheapest stock of Indian Curiosities ever opened on the

ISLAND OF MACKINAC,

CONSISTING OF

Bark Boxes, Trunks, and Baskets of every description. Sweet Grass in every variety of work, Bead Work, Feathers, Fans, Ladies' Bark Hats, &c. The assortment including every description of Fancy Work made by Chippewa Indians. Also, Photographic and Stereoscopic Views of all Points of Interest.

A FULL ASSORTMENT OF

CHOICE CANDIES,

FRUITS AND FANCY GROCERIES,

IN CONNECTION.

Ladies and Gentlemen visiting the Island should not fail to call and examine this stock. Inquire for S. HIGHSTONE'S Indian Curiosity Store, opposite his DRY GOODS STORE, on Water Street.

S. HIGHSTONE.

A large variety of DRY AND FANCY GOODS, CLOTHING, BOOTS AND SHOES, &c.

MACKINAC, *June*, 1875.

(95)

ADVERTISEMENT FOR AN "INDIAN CURIOSITY STORE" ON MACKINAC ISLAND, 1875. As the physical presence of what travelers called "wild Indians" was fading, the interest and curiosity of Native Americans was not. Many stores capitalized on the curiosity of travelers to seek Native-American goods. (From *Island of Mackinac*, by J. Disturnell, 1875.)

120

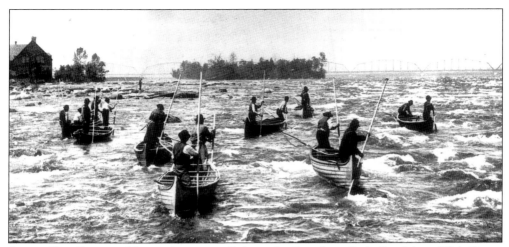

SCOOP NET FISHING. Native Americans Fishing the Rapids at Sault Ste. Marie With Scoop Nets. (From the Collection of Jack Deo.)

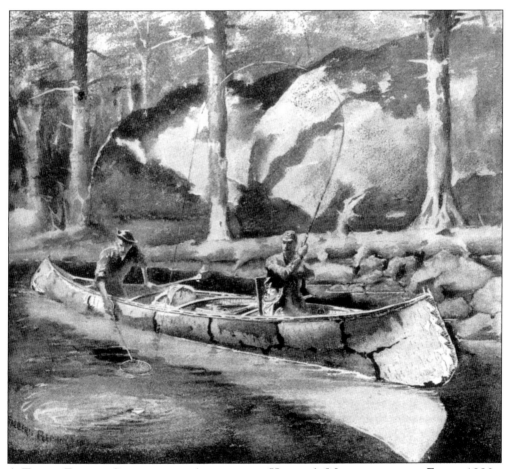

A TROUT FISHING SKETCH THAT APPEARED IN HARPER'S MAGAZINE IN THE EARLY 1890S. (*Harper's Magazine*, December 1891-May 1892.)

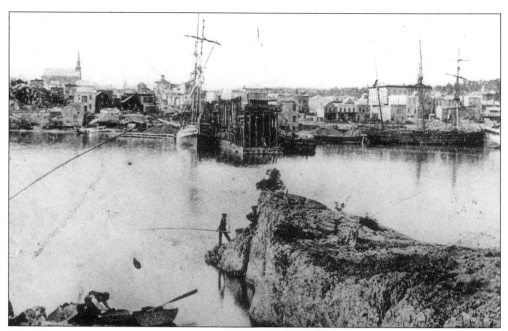

FISHING OFF OF RIPLEYS ROCK, OPPOSITE THE ORE DOCKS AT MARQUETTE IN THE 1860S. (From the Collection of Jack Deo.)

OVERLOOKING THE ORE DOCKS AT MARQUETTE. (From the Collection of Jack Deo.)

ADVERTISEMENT FOR T. MEADS STORE IN MARQUETTE. The store catered to local as well as tourist outdoorsmen and women. (From *Swineford's History of the Lake Superior Iron District*, by A.P. Swineford, 1871.)

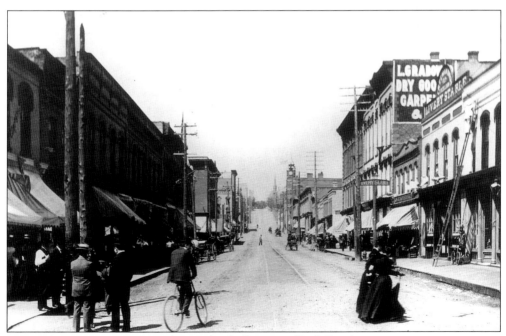

FRONT STREET, MARQUETTE. (From the Collection of Jack Deo.)

AN INTERESTING
PHOTO OF
MARQUETTE BAY
BY MOONLIGHT,
TAKEN BY B.F.
CHILDS. (From
the Collection of
Jack Deo.)

PHOTO NEAR PICNIC ROCKS IN MARQUETTE. (From the Collection of Jack Deo.)

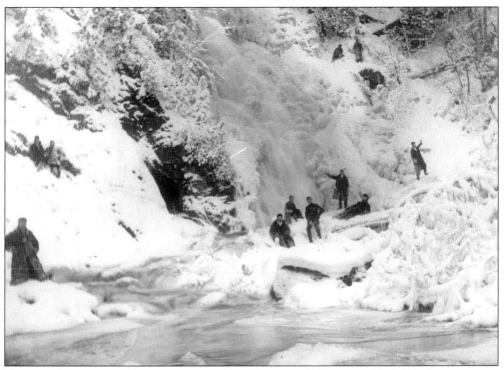

DOUGLAS HOUGHTON FALLS IN THE 1890S. (From the Collection of Jack Deo.)

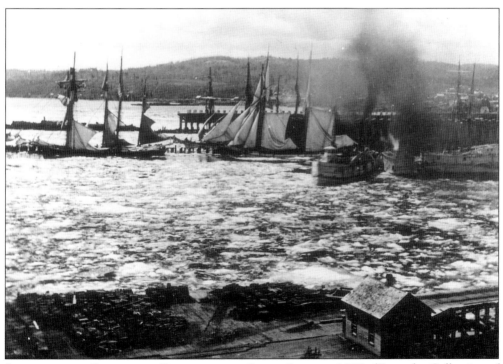

STEAMERS AND SCHOONERS BLOCKED IN BY ICE IN JUNE OF 1873. (From the Collection of Jack Deo.)

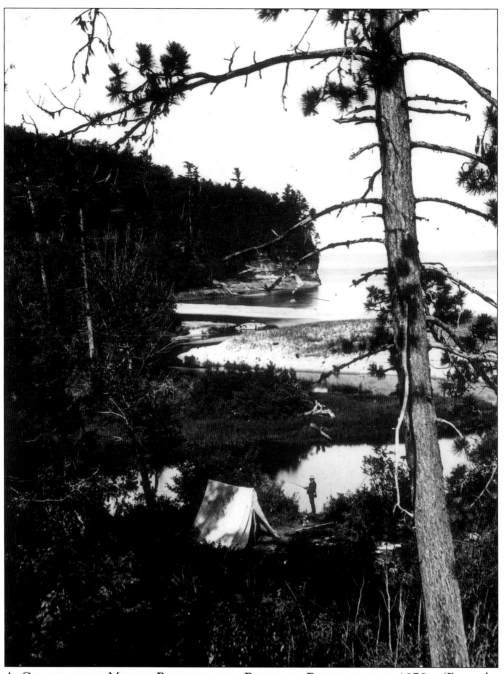

A **Camper near Miners River in the Pictured Rocks in the 1870s.** (From the Collection of Jack Deo.)

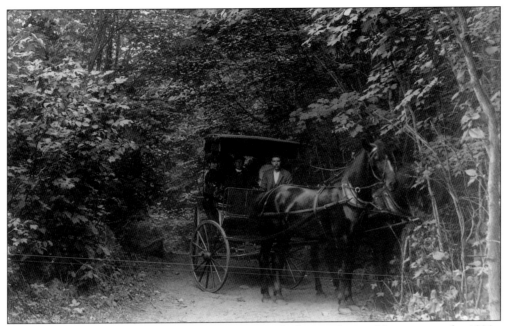

HORSE AND BUGGY. A horse and buggy trail through the woods near Marquette in the 1890s. (From the Collection of Jack Deo.)

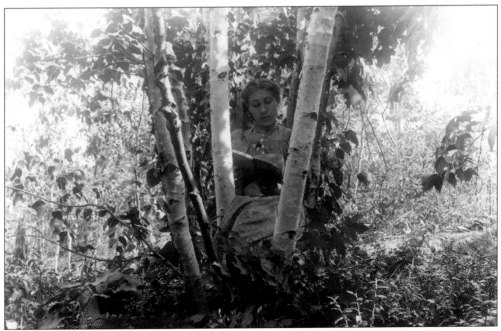

A WOMAN NESTLED IN BIRCH TREES FINDS SOLITUDE WITH A BOOK. One guidebook in the late 1800s touted the forests of the Upper Peninsula by suggesting travelers will enrich their lives by making the journey to Lake Superior Country. The guidebook claimed: "the great trees, the gentle murmur of the wind, the rich and beautiful carpeting of mosses and wildflowers, the constantly changing vistas, and the restful quietness—all these and more combine to make such an experience rich in pleasure and profit, both to the mind and the body." (From the Collection of Jack Deo.)

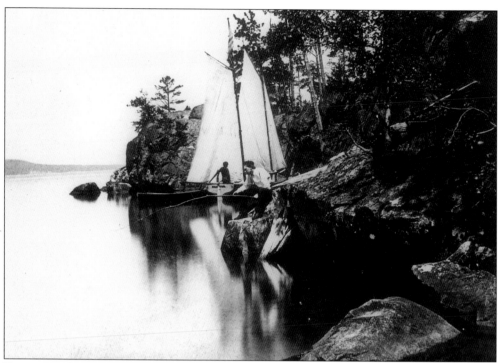

FISHERMEN OFF OF MIDDLE ISLAND POINT IN THE 1870S. (From the Collection of Jack Deo.)

Suggested Reading

Brehm, Victoria, ed. *The Women's Great Lakes Reader*. Duluth, Minn: Holy Cow Press, 1998

Carter, James L. *North to Lake Superior: The Journal of Charles W. Penny*. Marquette, Michigan: John M. Longyear Research Library, 1970.

Havighurst, Walter, ed. *The Great Lakes Reader*. New York: Collier Books, 1966.

Havighurst, Walter. *The Long Ships Passing: The Story of the Great Lakes*. New York: Macmillan, 1961.

Lankton, Larry. *Beyond the Boundaries: Life and Landscape at the Lake Superior Copper Mines, 1840–1875*. New York: Oxford University Press, 1997.

Magnaghi, Russell M. and Michael T. Marsden, eds. *A Sense of Place: Michigan's Upper Peninsula*. Marquette, MI: Northern Michigan University Press, 1997.

Martin, John Bartlow. *Call it North Country: The Story of Upper Michigan*. New York: Alfred A. Knolf, 1944. Reprint, Detroit: Wayne State University Press, 1986.

Nute, Grace Lee. *Lake Superior*. New York: Bobbs Merrill Company, 1944. Reprint. Minneapolis: University of Minnesota Press, 2000.

Rydholm, C. Fred. *Superior Heartland: A Backwoods History*. Marquette, Michigan: C. Fred Rydholm, 1990.